Lee Miller

Roland Penrose

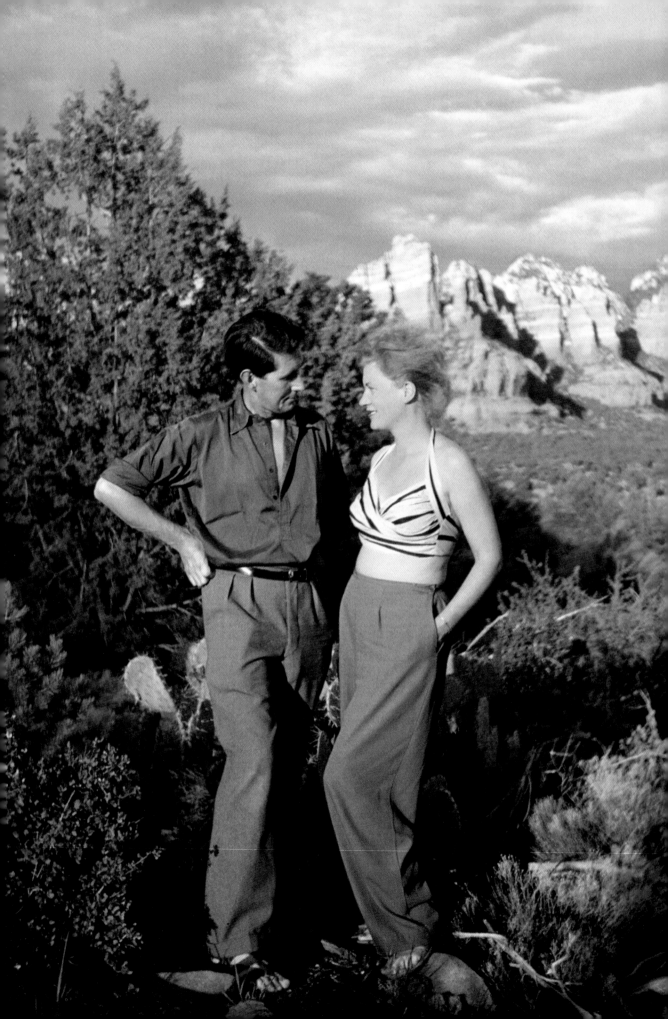

Katherine Slusher

Lee Miller
Roland Penrose

The Green Memories of Desire

Prestel Munich | Berlin | London | New York

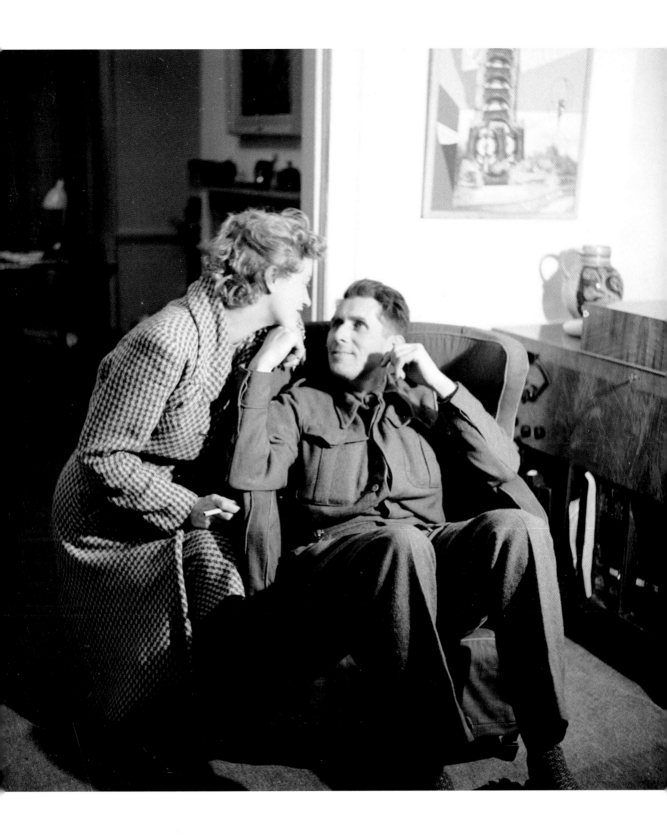

David E. Scherman
Lee Miller and Roland Penrose, Downshire Hill, England
c. 1943

A Marriage of surrealists

Roland Penrose met Lee Miller's lips a year before he met the rest of her. This was a fitting introduction for two artists who were linked by an art movement that delighted in chance encounters. Penrose, "the man who brought Surrealism to England," made that revolutionary body of work accessible, rocking the conservative and insular British art world through the 1936 Surrealist exhibition in London. Miller was an internationally renowned photographer whose Surrealist vision created a unique body of work documenting important personalities of the 20th century as well as recording a searing photographic and written testimony of World War II. Together they forged a life joined by a common cause — Surrealism.

Lee Miller and Roland Penrose are names that are recognized in a variety of different contexts. Penrose's numerous books and other publications made not only the work of Picasso comprehensible to a broader public, but also that of Miró, Man Ray, and other 20th-century masters. He was a distinguished, involved, and active participant in the politics of the time while remaining an ardent pacifist.

Lee Miller was known as one of the most stunningly beautiful, liberated women of the 20th century. Her name often evokes the word "muse" and is closely associated with Man Ray and 1930s' Paris. Lee Miller and Roland Penrose are not always associated with each other and it is not generally known that they were both artists in their own right and had a relationship that spanned forty years. They were married in England after the war, had a son, and created a home in the Sussex countryside that drew people from all over the world, among them the artists Max Ernst, Joan Miró, Henry Moore, and Pablo Picasso. And while Lee and Roland each lived extraordinary lives and collaborated on many projects, from publications to international diplomacy, they were both remarkably reticent in later years. For both of these decidedly singular creators, the postwar period meant revealing little about themselves and almost nothing about their earlier accomplishments.

Over the past three decades, thanks to the unflagging and often Herculean efforts of their son, Antony, their lives and achievements have rightfully taken their place in the history of 20th-century art. Though Lee's photographs and Roland's paintings have been published in one volume, exhibited simultaneously, and individually analyzed, the two bodies of work have been viewed as distinctly separate. In examining their love affair and their work, however, it becomes clear that their relationship, both personal and professional, was anything but disparate; it was an inspirational exchange of ideas, creating a dialogue of images and a catalyst for their work.

In the late 1920s and early 1930s, prior to their meeting, both Lee and Roland had been involved in the burgeoning Surrealist movement in Paris. Lee Miller was endlessly photographed by her then lover and mentor, Man Ray, in a variety of poses — standing beside a window, her torso crosshatched by the shadows of a lace curtain, or in another image, her perfect profile enhanced by the solarization technique they discovered together. But Man Ray's photo-

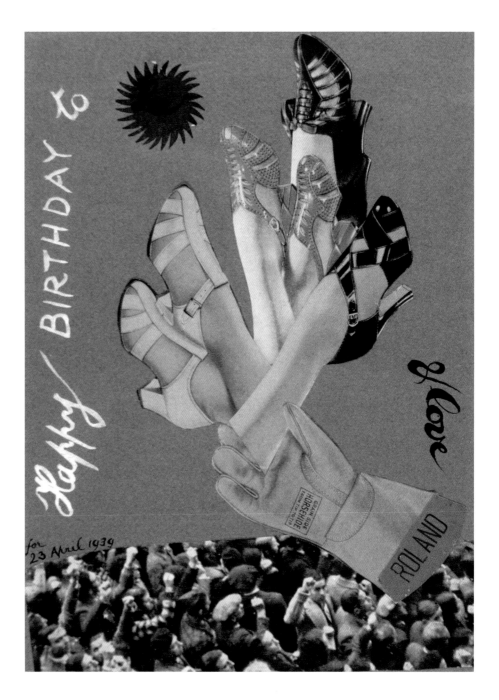

Roland Penrose
*Bouquet of shoes,
Happy Birthday
to Lee*
1939
Collage on card
21.5 × 15.5 cm
A. & R. Penrose

graphic depictions of his muse were not limited to the delights of their love and her beauty. *Object To Be Destroyed*, the piece he reworked when Lee left him, said it all: Lee's eye, photographed, cut out, and attached to the pendulum of a metronome. Each swing of the rod signalled his anguish at the end of their romantic involvement and life together in Paris.

What is a mystery in most people's minds is how an American girl from Poughkeepsie ended up on the cover of *Vogue* representing the quintessential look and style of 1920s' New York, moved on to take her place at the center of the Surrealist effervescence in Europe, then returned to New York City to open her own successful photographic studio, all before she was twenty-five years old. She quickly tired of taking society photographs, which made the

marriage proposal from a wealthy Egyptian, Aziz Aloui Bey, an even more attractive proposition than it was when she knew him in Paris. The rich body of photographs taken over the next several years on her Egyptian journeys into the desert as she explored isolated villages and the wide open barren spaces has yet to be fully examined. In 1937, while still married and living in Egypt, she met and fell in love with Roland Penrose on a trip to France one summer. A rich and moving correspondence ensued between the two which not only reflects their passion for each other, but also stands as a remarkable record of the time they lived in. At the start of the war in Europe, Lee moved to England and settled into a home in Hampstead with Roland. It was there that Miller supplemented her day job as a fashion photographer with her ironic and Surrealistic view of the destruction that surrounded her during the bombing of London. Once again in the right place at the right time, Lee convinced *Vogue* magazine to send her as a freelance contributor to cover the war, and thus began her work as a war correspondent and later as a combat photographer. She created one of the most gripping testimonies of World War II through both her images and her journalism. Her impeccable timing and sixth sense held true, and she scooped the siege of St. Malo three weeks after D-Day. She photographed live combat there and the US military's first use of napalm. Miller moved across Europe with the 83rd Division and was among the first photojournalists to go into Buchenwald and Dachau concentration camps. She witnessed and photographed the worst side of humanity, but she also photographed some of the best. Her portraits of artists, actors, and intellectuals are a fascinating record of those individuals and of the times. She captured the often elusive feel and the aura of her sitters in her photographs of Margot Fonteyn, Clark Gable, Jean Cocteau, Charlie Chaplin, Marlene Dietrich, Colette, Fred Astaire, Alec Guinness, Gala and Salvador Dalí, Gertrude Lawrence, and Dora Maar, and they remain among the finest images in photographic portraiture of the 20th century.

Roland Penrose, raised in a strict British Quaker family, became a heartfelt disciple of the Surrealist art movement. He was enthralled by the visual vocabulary of the art work and its fascination with dreams and dream states, chance encounters, the unconscious, free association, and hybrid figures which were often part-human, part-animal, and part-machine. The fact that he was instrumental in bringing Surrealism to England is unknown to most people. So is the fact that he was a dedicated and talented Surrealist artist in his own right. His genuine friendship and support of the artists he admired, believed in, and associated with led him to begin an art collection that "collected itself" and became the backbone of the early 20th-century collections in the Tate Gallery, London and the Scottish National Gallery of Modern Art, Edinburgh with works by Braque, Picasso, Ernst, de Chirico, Man Ray, Tanguy, Magritte, and Giacometti. With his innate diplomacy and his friendly manner, Penrose managed to forge an important friendship with Picasso, allowing him entry into the artist's homes, studios, and private life.

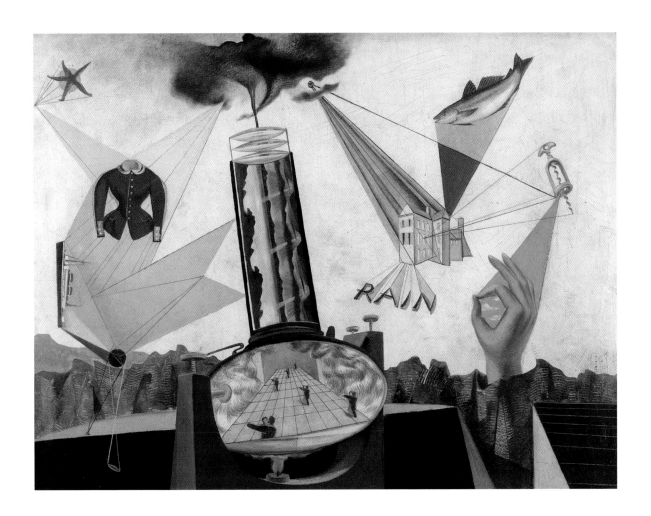

Penrose was a witness to three wars in his lifetime; he was active during both World Wars and his support of the Republican cause in the Spanish Civil War led him to Barcelona at a crucial time, the onset of the war. His combined attributes of intellect, charm, and diffidence gave him the perfect balance for a diplomat and patron of the arts. After the war, he was faced with the choice of continuing his personal production as an artist or working to make other artists accessible to the world. He selflessly chose the second option and continued tirelessly to organize exhibitions and art events of primary importance. At the same time, he worked steadily towards his dream of creating a museum dedicated to modern art in Britain which was to become the Institute of Contemporary Art in London which he not only co-founded in 1947 with Herbert Read, but helped finance by sales from his personal art collection. In 1956, Penrose took a post as Fine Arts Officer for the British Council in Paris, and continued to write about artists such as Man Ray, Joan Miró, and Antoni Tàpies, while becoming a Picasso expert with numerous publications on the great artist that have been republished and translated extensively. In recognition of his significant contributions to the arts, he was knighted, becoming, as he ironically put it, a "Sir Realist."

Roland Penrose
Le Grand Jour
1938
Oil on canvas with collage
76.2 × 101 cm
Tate Gallery

Observatory Time—The Lovers

Roland Penrose's first encounter with Lee Miller was in a painting and as so often happened to Lee, it was not all of her, but just a partial portrait. In keeping with the Surrealistic aesthetic, Man Ray's painting, *Observatory Time—The Lovers*, showed Lee's disembodied lips, floating above a landscape. In her early years in Paris, she had often been dissected by a camera and broken down into pieces: an eye or a hand, her neck, her torso, and most enigmatic of all, her mouth. Lee had intelligence and a mesmerizing, dazzling beauty that seemed to energize everyone around her, combined with a madcap sense of humor. There was more to her than pure physical beauty. Her presence had a force behind it and everyone wanted to be caught in the energy that emanated from her. Roland had never met anyone quite like her in her zeal for life, her quick American wit, her relaxed elegance and the easy comfort with her body. And so it was that he saw her lips there, framing an alluring smile with an enigmatic yet commanding presence. Both playful and seductive, from a distance they appeared as two red intertwined bodies in a passionate embrace. They were floating on a cloud-scattered sky of blue in a large oil painting by Man Ray that spanned the entire width of the doorway at the First International Surrealist Exhibition in London.

This show, which Penrose had helped curate, promote, and organize, opened in June 1936 to massive crowds. The Surrealist royalty was there from France: their leader André Breton, the poet Paul Eluard, and his ethereal muse Nusch, who, besides Lee, was the most painted and photographed woman in the group. The antics of Salvador Dalí, already an established artist, were in full play; he decided to give his lecture in a diving suit flanked by two large stylized Irish wolfhounds and almost suffocated before the heavy domed helmet could be pried off his head.

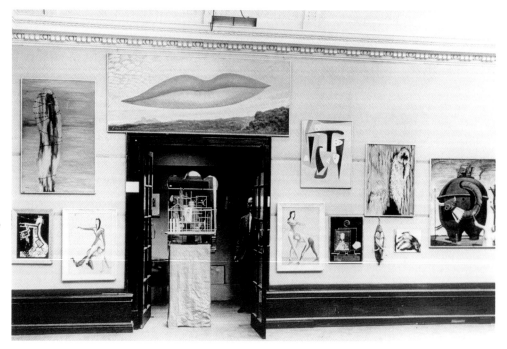

Unknown photographer
Man Ray's painting "Observatory Time—The Lovers" over the doorway at the First International Surrealist Exhibition, New Burlington Galleries, London
1936

10

It was a seminal exhibition for the Surrealist art movement and one of the major contributions to 20th-century contemporary art. As Penrose described it years later: "It was a roaring success and it has become a milestone in the understanding of modern painting in England."[1] There were painters from all over and, for the first time, the international names in Surrealism were exhibited alongside their British counterparts, many of whom had been working in isolation in their studios scattered across the British Isles.

After the exhibition closed, Paul Eluard invited Roland to visit them in the South of France in August.[2] It was there that Penrose met the other significant source of inspiration and total devotion in his life, the artist Pablo Picasso. Until the end, his passion for the artist would be, like so many other aspects of his life, a shared endeavor and a vital link to Lee Miller, the woman who was to become his companion in art and in life.

Roland Penrose
Lee Miller, Lambe Creek, Cornwall, England
1937

Lee Miller's early years in upstate New York and Roland Penrose's in rural Oxhey Grange were similar in many ways. They were both born into financially comfortable families at the turn of the century surrounded by a household of brothers and a large farm to explore. Elizabeth Miller (who changed her name to Lee at twenty) was born in 1907 in Poughkeepsie, New York, as a rebellious, free spirit in puritan America. Hers was the seemingly typical American family. Her father, Theodore Miller, was a successful engineer and her mother, Florence MacDonald, a Canadian, worked as a nurse before marrying in her mid-twenties. Lee was the middle child between two active brothers and being close in age, the three were rambunctious and inventive, building locomotives and mixing multiple concoctions with her cherished chemistry set. Lee was her father's favorite which may account for his frequently troubling (and enduring) interest in photographing her, dressed and, more often, undressed from birth into her early twenties. Perhaps more disturbing was his use of a stereoscopic camera showing the naked, mature Lee in her three-dimensional glory.

When Lee was seven years old this bucolic lifestyle came to an abrupt halt. While her mother was recuperating from a brief illness, Lee was sent to spend the weekend with close family friends in Brooklyn. This couple delighted in her buoyant and exuberant charm and energy. She was left in the care of a relative of theirs for a few hours and in that time she was raped. Her son, Antony, only found out about the incident after her death, since she never spoke of what happened. The exact identity of her assailant remains unknown and what little has come to light was pieced together by her younger brother, Erik. What made the event even more unbearable and traumatic was that Lee contracted gonorrhoea as a result. The treatment in those days was a succession of baths and douches with antiseptics and acids; her brother Erik recalled being sent away from the house with their older brother, John, during the painful treatment so as not to hear her screams. Their mother, with her nurse's training and the desire to keep their daughter's illness hidden from everyone, performed the daily ritual of douching and treating Lee, alongside a manic sanitizing of everything that Lee touched.

This shocking event had lifelong consequences for Lee when it came to her perceptions of love, sex, and the relationship to her own body. To a child the treatment must have seemed a continuing assault on her combined with the daily insinuation that there was something dirty and wrong with her body that only vast amounts of scrubbing could solve. As if that were not enough for a seven-year-old to absorb, her parents, fearing emotional damage, consulted a psychiatrist who told them they must make her understand the separation of love and sex. Perhaps it was as a result of this advice, or the hypersexuality that frequently surfaces in adults who had been sexually assaulted as children, but in later life Lee would be sexually uninhibited and practised free love years before its time. Her seemingly stable family life was further complicated by the tensions created by her father's ongoing infidelities, causing her mother to question her marriage in the same way she had once questioned her courtship.

Unknown photographer
The Miller Family
1923

Theodore Miller
Elizabeth (Lee Miller), John and Erik Miller, and "Loco", Poughkeepsie, New York
1913

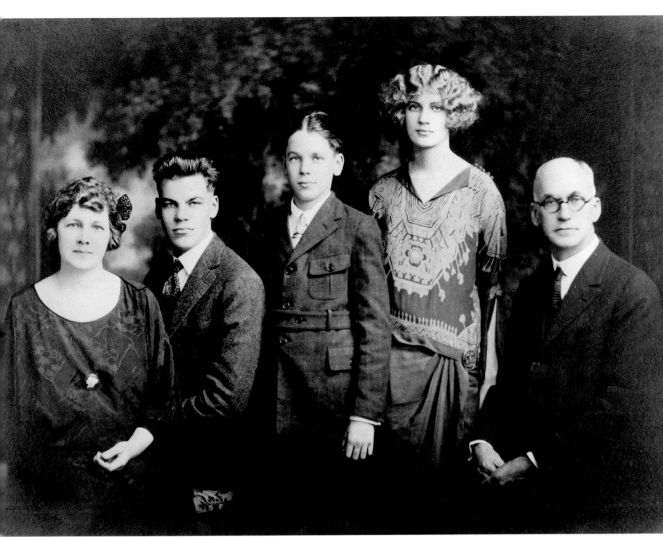

13

To everyone around her, Florence seemed to be a passive, long-suffering wife when, in truth (according to Theodore Miller's nominal descriptions in the diaries he kept), she had tried at least once to take her own life.[3] Whatever differences the Millers had they appeared to resolve themselves, since they remained together and Florence died shortly after celebrating their fiftieth wedding anniversary.

Lee grew up photographed, adored, and indulged by her father, while remaining a high-spirited prankster. This no doubt contributed to her being expelled from every school she was enrolled in for mischievous behavior; her imaginative antics and rebellion against authority were not appreciated by any of the schools she was sent to, be it Quaker or Catholic. She completed her last year of schooling without incident, studying French and drama, and at eighteen went to France with her French teacher as chaperone for the summer. After several days in Paris, Lee had no qualms about eluding both her chaperone and the plans to take her to a finishing school in Nice. Lee convinced her parents to let her stay in the city to study art for the fall term. As Lee recalled later in life: "One look at Paris and I said, 'This is mine—this is my home'."[4] She rented a small room and enrolled in a progressive theater school which trained students in the applied arts of lighting, costume, and design as well as experimental drama.[5] She revelled in her four months of freedom, exploring all the *quartiers* of Paris and living "la vie bohème." Her parents arrived in October and her mother Florence stayed with her until the end of her academic course. They sailed back to New York together after the New Year. Back in Poughkeepsie, Lee enrolled in the new drama program at neighboring Vassar College. The program was run by the progressive-thinking Hallie Flanagan, who later became better known as the WPA's Federal Theater Project Director under Franklin D. Roosevelt.[6] Lee was in charge of lighting for several productions, but after her taste of freedom, she was anxious to escape small-town America. She spent more and more time going to New York City where she began taking dance lessons and had a short stint as a chorus dancer for the George White Scandals, similar to the better-known Ziegfeld Follies. That fall, Lee enrolled at the Art Students League where she studied drawing and met her lifelong friend Tanja Ramm who, with her dark beauty and sweet temperament, was the perfect counterpart to Lee. But Lee soon realized she did not have the patience or obsession with painting to pursue the medium. At heart she was a rebel wanting to embrace life, not contemplate it quietly behind an easel in a studio.

Unknown photographer
Lee Miller
c. 1914

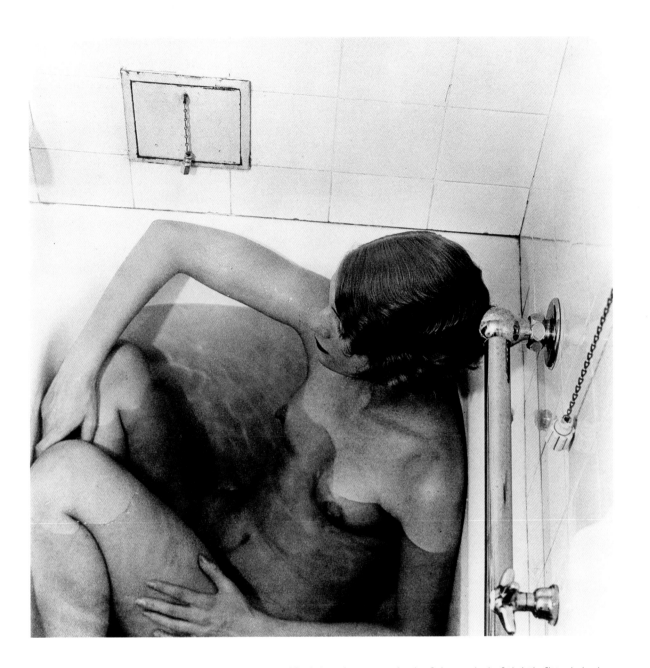

Theodore Miller
Lee Miller in Bathtub, Grand Hotel, Stockholm, Sweden
1930

Lee personified the glamorous look of the period of tightly fitted cloche hats, sculpted, marcelled hair, and flapper dresses. Shortly before her twentieth birthday, she was "discovered" in dramatic circumstances reminiscent of a classic Hollywood film of the golden era. Lee stepped out into traffic on a busy street in Manhattan and was pulled back to safety into the arms of Mr. Condé Nast himself, the powerful editor of *Vogue*, the top fashion magazine of the period. Charmed by her babbling French and personal style, Condé Nast put Lee on the cover of *Vogue* in a drawing by Georges Lepape. This in turn led to a whirlwind career as a fashion model and she went on to be photographed by the elite in fashion photography of the era. Lee's photogenic face and long, lean elegant body became a particular favorite of the photographer Edward Steichen. Lee Miller's name soon became as well known as her face, predating by decades the cult of the modern-day supermodel.

15

Her ever-enquiring mind and curiosity were not wasted in these sessions. She had grown up surrounded by and interested in her father's photographic equipment and darkroom, and now became increasingly fascinated by the medium of photography and its artistic potential. Through her modelling, she had the equivalent of master classes with illustrious professionals such as Nickolas Muray and Arnold Genthe, which further stimulated her interest.

Lee's modelling career ended abruptly when a photograph of her was used in a nationwide advertising campaign for Kotex sanitary napkins. Magazines, and more specifically fashion houses and magazine advertisers, did not want to be associated with such an embarrassingly private and unglamorous hygiene product, and so the "Kotex girl" soon found herself out of work.

Kotex Advertisement from "Delineator"
March 1929
Courtesy of Harry
Finley

16

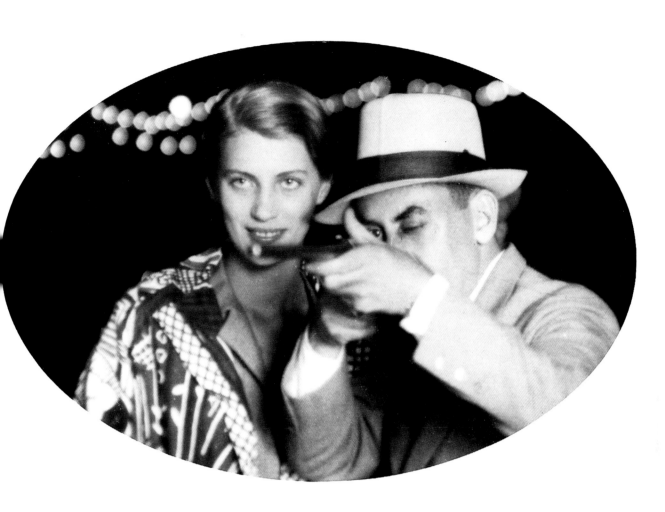

At twenty-two, Lee was longing to return to Paris and the life she had experienced there. It was as if she not only welcomed, but sought out a life full of risk and complexity and the Kotex disaster was the impulse she needed. With introductions to the editor of French *Vogue* and an introduction from Steichen to the photographer Man Ray, she and Tanja booked their passage and sailed for Europe. On her arrival in Paris, Lee went directly to Man Ray's studio in Montparnasse and was told he had left for the South of France for the summer. She then went to the chic neighbourhood café, the Bateau Ivre, to ponder her alternatives, and once again, her good fortune held. As she was sitting there sipping a Pernod on ice, Man Ray appeared out of nowhere. As Lee described how she became a photographer in an interview years later, "I started out with one of the great masters in the field, Man Ray. He didn't take students as a rule. He was in Paris at that time and so I went to him and said, 'Hello, I am your new student and apprentice.' He said, 'Oh, no you're not, I don't take students or apprentices.' I said, 'You do now'. And I worked with him for four years."[7] Shortly thereafter, Lee left with him for their summer together in Biarritz and that was the beginning of Lee's life as "Madame Man Ray."

Roland Penrose had also met Man Ray at around the same time via his friend and artistic mentor, Max Ernst. Ernst was one of the most exciting, prolific, and creative artists involved in Surrealism, constantly experimenting with new ways of working. He soon introduced Roland to the group of French Surrealists and he became an impassioned devotee. Max shared his artistic techniques of frottage (a method Ernst developed for using different textures and objects for rubbings), decalcomania (a painting technique where gouache is painted on paper and a second sheet is pressed on top creating a mottled, organic texture), and collage (which he used with a very different intent from the Cubists). In the hands of Braque and Picasso, *papier collé*/collage had been largely structural and compositional, but Ernst gave it another life as a means of expressing the Surrealist precepts of strange, dreamlike scenarios or unexpected juxtapositions of disparate objects. Roland explained how stimulating the borrowed surfaces used in frottage were for an artist. In a speech on why he became a painter, he described it thus: "This process reminds one of the advice given by Leonardo to his pupils that when they wished to find new ideas for a picture they should study the stains on a dirty wall and would find therein warriors, dragons, mountains, and rich nourishment for their imaginations."[8] Penrose felt that Ernst had opened doors into a wonderful new world for him. Like Lee, it was in Paris that Roland's world expanded and took flight in hitherto uncharted directions.

Roland was born in 1900 in Watford, near London, into a strict Victorian Quaker family. In another coincidence of their upbringing across continents, Lee Miller's family had by chance settled in a Quaker enclave and she had boarded in a Quaker school for two years. Roland's father, James Doyle Penrose, was an Irish portrait painter who had studied at the Royal Academy in London and a gentleman farmer. His mother, Josephine Peckover, was the daughter of Lord Peckover, a wealthy Quaker banker. Roland was the second of four brothers, and like his elder brother Alexander and his two younger brothers Lionel and Bernard (Beacus), he was sent to a Quaker boarding school. When he was a child, Roland's family moved to Oxhey Grange, northwest of London, where they lived in a large Tudor mansion surrounded by acres of farmland to explore. The family holidays were spent with their maternal grandfather and Josephine's two maiden sisters on his estate, Bank House, in Wisbech, north of Cambridge. Summer days for the entire family were taken up in sketching and painting out of doors. Roland in particular was entranced by his grandfather's library and spent countless hours exploring the magical Victorian cabinet of curiosities which he was later to recreate in his own home in Sussex. The juxtaposition of the most exotic of objects, each from a different corner of the world, created a world of magic and fantasy not otherwise available in his life. To a dreamer such as Roland, this was the catalyst to his imagination and a key turning point in his life. The mythical world of floating nude women and windblown creatures in Edward Young's *Night Thoughts* illustrated by William Blake was mesmerizing when he discovered it tucked away at the

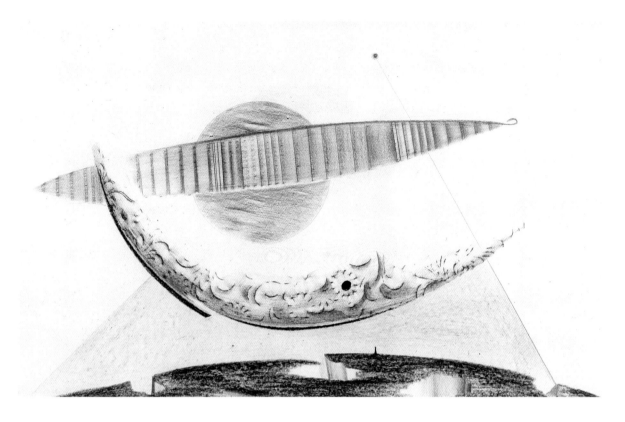

Roland Penrose
Eclipse of the Pyramid
c. 1930
Pencil frottage
and drawing
31×47.5 cm
A. & R. Penrose

bottom of the bookshelves. As he later said, all English literature is full of Surrealism from Shakespeare onwards.[9] Like most things of mystery and magic, it is only a matter of looking for it and recognizing it when you see it.

As a young man, Roland would frequently escape to his uncle's working farm in Sussex. It was there that he grew to love the beauty of the Downs with their softly rolling green hills and ancient history. It is no coincidence that years later Roland would choose to settle in the Sussex-located Farley Farm, and run his own dairy farm while also continuing with his more esoteric and aesthetic interests in the arts.

The Penrose family, seen through today's eyes, was both very contemporary and very conservative. They lived in upper-middle-class Britain and were very much a part of that social realm. As practicing Quakers, they were pacifists who followed their own inner moral beliefs. They had a tolerant worldview, yet at the same time they were unworldly in that they lived in an "enclosed" society of their own. Roland was in his mid-teens at the outbreak of the Great War. As a Quaker he was, like his brothers, a conscientious objector and therefore given exemption from combat duty. Instead, the three eldest Penrose sons served in various ambulance units and at seventeen, Roland was sent to Italy with the First British Red Cross Ambulance Unit. There he had not only his first glimpse of the wonderful religious artworks in the Veneto region, but also of the death and destruction that was wrought by war. Fortunately, the war was over in a matter of months, and without a pause Roland left for Cambridge and enrolled at Queens' College, not far from where his brother Lionel was studying at St John's College and his brother Alec at King's. Like many artists

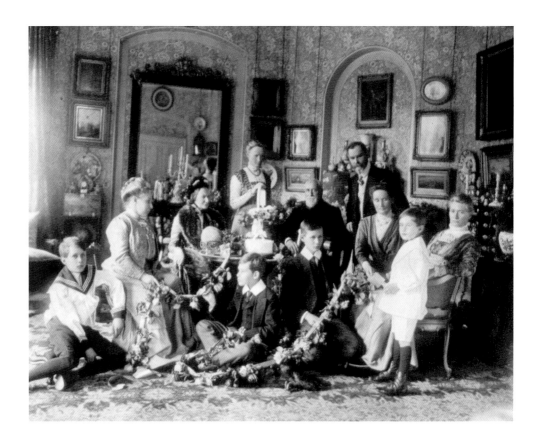

before and since, Roland was actively encouraged by his family to study some-
thing practical such as architecture, instead of art. At college, he took advantage
of the wealth of extracurricular activities open to him: he enrolled in the drama
society and was invited to Sunday evenings with the economist John Maynard
Keynes, whose splendid art collection contained the first Cubist works by
Braque and Picasso that Roland had ever seen, as well as paintings by Matisse
and Cézanne. Through Keynes, Roland and his brothers were introduced into
the very special and insular world of the Bloomsbury Group. Roland became
particularly close with the art critic Roger Fry who organized the landmark
exhibition on Post-Impressionism which was the precursor to Roland's survey
of Surrealism years later. The brothers also met and socialized with the other
Bloomsbury artists and writers Duncan Grant, Vanessa and Quentin Bell,
David Garnett, Leonard and Virginia Woolf. Roland recalled visiting them at
their country home, Charleston, in Sussex, which once again took him back to
the county he had been so drawn to as a young man.[10]

Roland did not achieve his full liberation from the more puritanical
aspects of his upbringing until he went to Paris. He graduated with a degree
in architecture, but his father, James Doyle, was disappointed that he wanted
to go to Paris to study painting. Once there he studied with André Lhote and,
stimulated by his teacher's enthusiasm for Cubism as well as the Cubists'
passion for African art, he began expanding his technique.[11] Looking back at
these early years, Roland recalled the first artist he met who left a lasting
impact on him — the Cubist artist Georges Braque. Roland described that

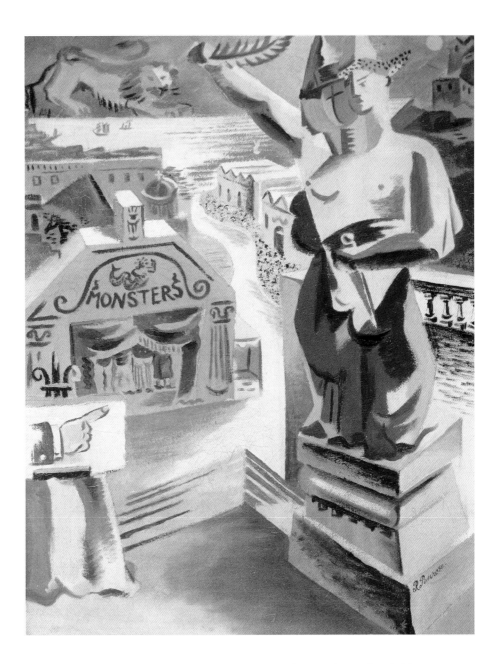

Roland Penrose
Monsters
1925
Oil on canvas on panel
64.2 × 50.2 cm
A. & R. Penrose

meeting in an interview: "That was a great influence immediately, his presence, his personality… to meet him like that in the flesh and find him a man of such charm in spite of the fact that I really hardly spoke a word of French impressed me enormously. I remember seeing him sit down with a reproduction of a Goya (*Naked Maja*) and look at it intently for a good quarter of an hour. I thought this is strange, I have never seen anybody look at a reproduction like that before. The intensity of his concentration was something new. It removed painting from being the amusing pastime that it had been before in my life."[12]

In Paris, Roland had met a young, affable Greek artist, Yanko Varda, with whom he shared an affinity for both art and pretty girls. As the summer approached, they decided to journey to the fishing village of Cassis-sur-Mer in the South of France where they found a house, Villa Les Mimosas, and built a studio in the overgrown garden. A painting from this period, *Monsters*, has

architectural structures that parallel Giorgio de Chirico's compositions, and its strong use of icons and symbols suggestive of Dalí and Surrealist themes: a hand, from the classic advertising signs, resting on a draped French flag; a cardboard theater named Monsters, whose cheerful yellow color and painted mermaid logo are at odds with the name; and the three-headed goddess holding a knife while offering a feather to a menacing lion on the Mediterranean horizon on a moonlit night.

It was in the village that Roland met his first wife, the serenely beautiful, mystical poet Valentine Boué, whom he married in 1925. As a young married couple, Roland and Valentine spent time together in France and England and travelled together to Egypt. In the way of kindred souls who have intersecting orbits, Roland visited and dined in what was to be Lee's Egyptian home in Cairo ten years later. After their travels, the couple decided to move to Paris and began hunting for a place to live and work. Through mutual friends, they heard that the artist Max Ernst was leaving his studio in Montmartre and that meeting was the beginning of their long and stimulating relationship. As Roland described: "I at once found him a very exciting character, very extraordinary with his brilliant blue eyes and his eagle-like appearance, and surrounded by his own paintings, which I thought were splendid, I liked them immensely at once. They seemed to me a new world. Also I came across that *Histoire Naturelle* (thirty-four *frottage* drawings published in a portfolio in 1926) which he had brought out about that time, about 1925, and was greatly impressed by that. So that started a great friendship with Max Ernst who of course was very much one of the Surrealists...an odd thing happened there, because looking round the studio I saw a picture hung rather high up on the wall. It was a big white canvas with a big blue splodge on it. That was all there was except some writing. At the top it had *Photo* very beautifully written, and underneath the blue splodge *Ceci est la couleur de mes rêves* — This is the color of my dreams. I went away thinking Max has really opened doors into a new world, the world of dreams, and the world of the imagination as I had never experienced before. It was not until some years later that I discovered that that picture was not by Max at all, it was by his neighbor Miró".[13]

Roland was immediately swept away into the wonderful stimulating world that he had entered. Already versed in the writings of Breton and Eluard, he took to Surrealism like a fish to water. He steadily established his own position as Surrealist artist and supporter; it was as if at last he had found something that transposed his Quaker beliefs into a meaningful participation in the desire of changing the world for the better. Later in life he was to say that he didn't think he could have been a Surrealist without having been a Quaker first. He discovered a significant meeting point between the beliefs he was brought up with and the Surrealist principles he adopted as his own. The idea of looking inward to follow an inspirational course applied to both, and he described this in an interview: "The Surrealists were very keen on dreams and the subconscious and Freudian interpretations, and there was

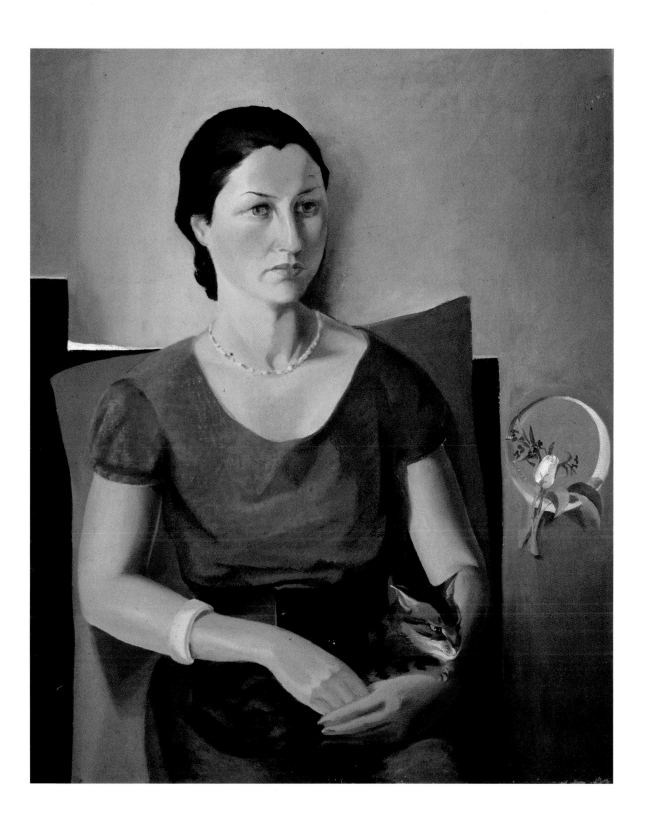

Roland Penrose, *Valentine with Cat*, c. 1932
Oil on canvas, 79.8×64.9 cm, A. & R. Penrose

always some slight thing, which seemed to be akin to the Quaker's Inner Light which was the guiding principle of any good Quaker. Also Surrealism was essentially international...and that was another point which was akin to Quakerism."[14]

Roland's portrait of Valentine is one of contemplation, stillness. In it she is completely static and pensive in a classically beautiful manner, reminiscent of Salvador Dalí's portraits of his sister and María Carbona from 1925. Roland and Valentine continued to travel together as the occasion arose, to Spain three months after the start of the Spanish Civil War in support of the Republicans against Franco's fascist takeover, then back to Egypt and finally India for four months. Upon their return to France, their paths began to take decidedly different directions. Valentine became more meditative and removed from the external world and finally decided to return to India. Roland was caught up in the excitement and his engagement with Surrealism. He was embraced by his friends as one of their own, with even the usually reserved and judgmental Breton calling him "le surréaliste dans l'amitié" (the friendly Surrealist). Roland and Valentine parted ways soon thereafter and were to divorce in 1939, although as world events would have it, they were reunited in the same household during the war years and remained friends until her death at Farley Farm in 1978.

Man Ray, besides being an established photographer, was one of the key players in the French Surrealist movement since its formal inception in 1924. He was not only attracted to Lee's *joie de vivre* and beauty, but he also felt he had found a kindred spirit in her wild sense of humor that was a counterpoint to his dry wisecracks made in a heavy Brooklyn accent. Their relationship was constantly evolving; she was his muse, his lover, and Surrealist model as well as his apprentice and assistant. Their work became so closely integrated that they often did not maintain individual ownership of images. At the time this was also a Surrealist ideal, and it only became problematic years later when trying to assign authorship. They were working together one day when they discovered the process of solarization which became an emblematic trademark in their work. It came about in an equally Surreal manner, to paraphrase one of the defining banners of the movement: it was as startling as the chance encounter of a mouse and a woman's foot on a darkroom floor.[15] As Lee explained it, she was developing film in the darkroom and something, perhaps a big mouse or a small rat, crawled across her foot. She rapidly switched on the lights and realized her exposed pictures were being ruined so she put them

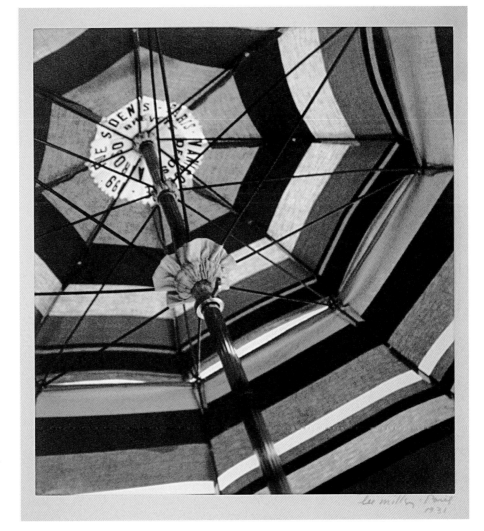

Lee Miller
Umbrella, Paris
1931
Vintage print
Philadelphia
Museum of Art

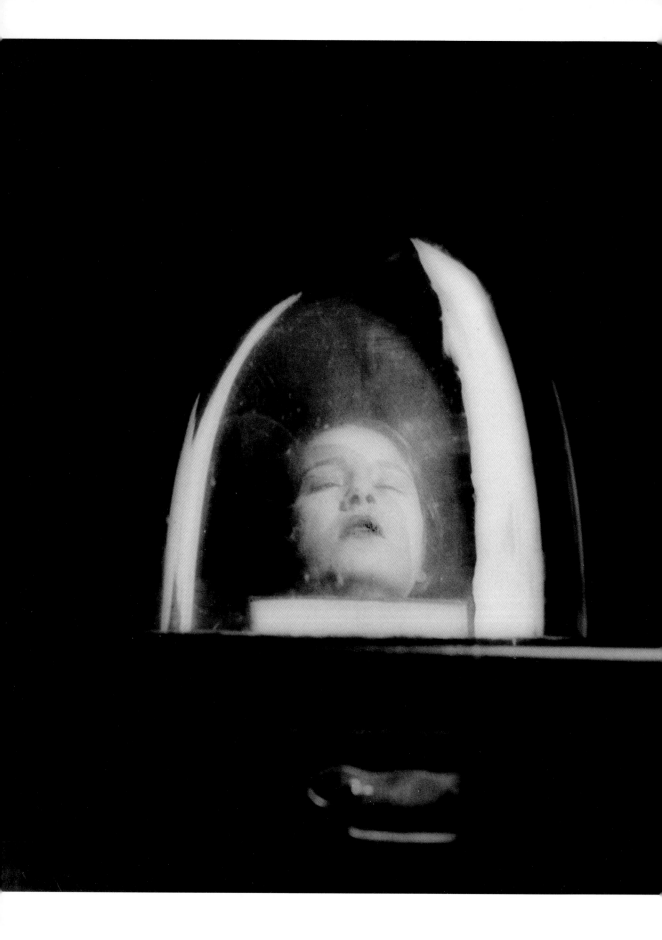

Lee Miller, *Tanja Ramm under Bell Jar*, Paris, 1931

Lee Miller, *Lilian Harvey, Solarized Portrait*, NYC Studio, New York, 1933

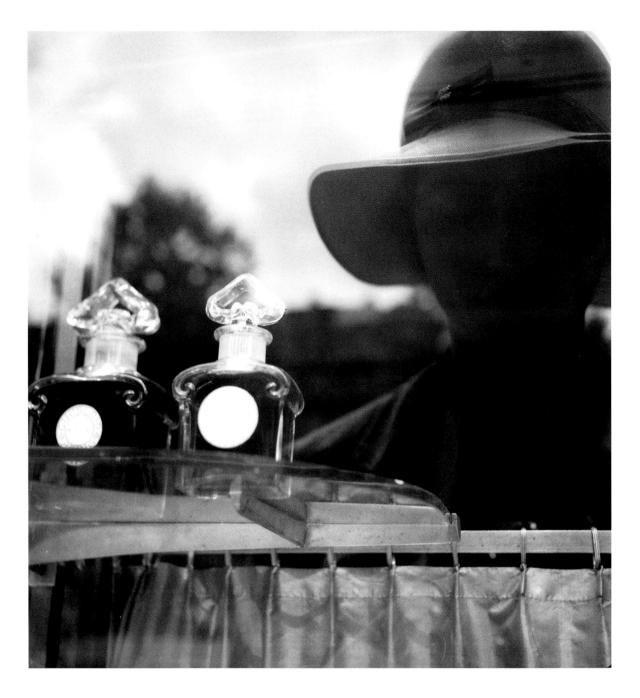

into the fixer bath immediately. The result was solarization, which reversed some of the light and dark qualities and created a fine outline around objects and people, giving them a mysterious presence and creating the perfect Surrealist tool.

For both artists, photography was a form of creative artistic experimentation as well as a means of paying the bills, and their professional lives were split between purely art photographs and their commercial output. Lee continued her work in fashion from both sides of the lens, which offered her a unique perspective. Along the way she had the opportunity to learn from some of the best in the field: George Hoyningen-Huene, Horst P. Horst, and Cecil Beaton. She continued to experiment and progress in her own work,

Lee Miller
Reflection of Lee Miller in the Guerlain Shopfront Window, Paris
c. 1930

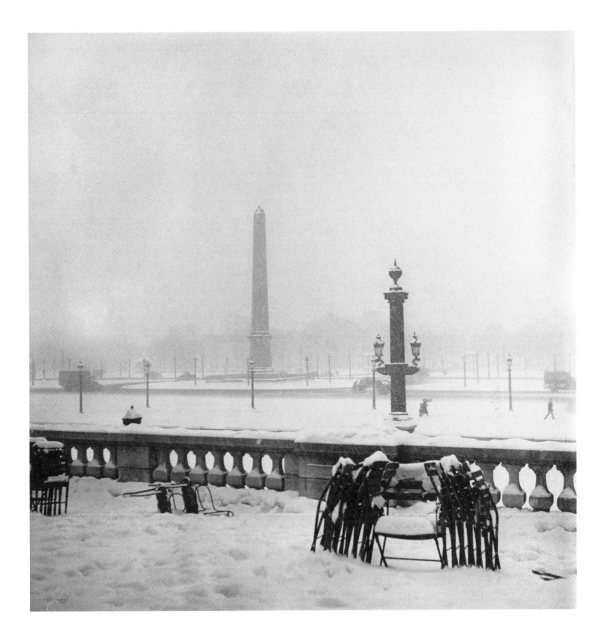

further and further defining her own style. There are traces of a constructivist aesthetic in the architectural studies she made of her apartment building as well as in the intersecting geometric stripes of images such as *Umbrella*. At the same time, Lee continued to explore a world of dreamlike mystery and the unconscious in photographs such as *Tanja Ramm under Bell Jar*. This image is significant not only as a portrait of Lee's close friend, but also as a document of the types of experimentation she was doing in her work which were similar to other photographers of the same period.

If there is a single element that unites Lee Miller's photographs, it is a pervasive world view that is undeniably Surrealist. For as much as she travelled, the essence of her work was not about the place where she was physically located. She often left a piece of herself in her work: this was sometimes done consciously, where her reflection is clearly discerned; at other times, it is just a hint of her presence. This oblique self-portraiture is something that

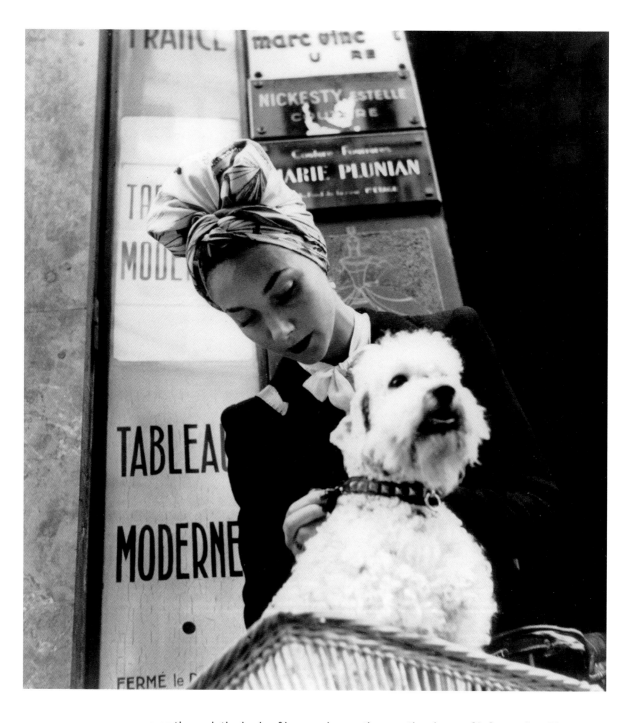

runs through the body of her work, creating another layer of information. The Guerlain shop window is suggestive in other ways; it hints at exotic travels to the Orient where Monsieur Guerlain became entranced and captivated with the scents in the air and brought that home in his memory to recreate in a small flask of perfume. In Lee's work, the human forms, architectural elements, objects, and street scenes are secondary; her images have more to do with portraying sensations, an odor, a moment in time, or even just the insinuation of a captured glimpse in passing. Her photograph of Paris under the snow, taken during the war years, carries her strongly Surrealistic aesthetic. It evokes the intangible: the crisp smell of snow, the feel of the flakes falling, the crunch

underfoot, the strange spider-like sculptures of stacked chairs, and then a half-discerned magical form appears, barely perceptible in the distance.

In the Parisian Surrealist movement, *l'amour fou* was designed by Surrealist men for men as an expression of their sexuality, their art, their fantasies, and their fetishes. Within this "liberal" and "liberating" movement, women were constrained to the traditional art-historical role of a passive object to be admired, mythologized, dressed, and undressed as the perfect accessory to the male artists' statement of who they were and how they interpreted their world.

Another Lee, the artist Lee Krasner, in discussing how the influx of European Surrealist artists in 1940 had impacted on the Abstract Expressionists working in New York at the time, remarked that the Surrealists treated their women like French poodles.[16] Lee Miller was no poodle by any stretch of the imagination (although she is known to have photographed them on occasion). She continued to socialize on her own terms with the principal figures in Surrealism — André Breton, Max Ernst, and Paul Eluard — without being completely absorbed or subjugated by their mandates. This also held true for her emerging photographic style. She pushed the boundaries and actively embraced Surrealism and its codes of conduct. Her sexual freedom and lack of sexual possessiveness provoked violent jealousy in Man Ray. Lee had a beautiful body, a generosity and freedom in sharing it in any way she felt fit, and was not to be intimidated. She took a role in Jean Cocteau's classic 1930 film, *Le Sang d'un Poète*, to the chagrin of Man Ray and the other Surrealists, who were idealistically at odds with him.

Their lives on parallel tracks, Roland Penrose had a part in the other Surrealist film of that year, *L'Âge d'Or* by Luis Buñuel, also financed by the Vicomte de Noailles. Buñuel's film was considered so subversive and sacrilegious and created such a scandal when it was shown that the release of Lee's film was postponed until two years later. Roland continued to become further and further immersed in his new world and it took on an increasingly significant role: "Surrealism became a cause to me. Surrealism was not just a new school of painting — it was a way of life — it was a way of thinking and a way of living which excited me very much indeed. A way of thinking which relied very much on spontaneity, the unconscious, and of course was very left-wing. Well, I had been that before. Quakerism was certainly not a right-wing movement, and I had a feeling there should be much more human justice and human understanding in society in general. Surrealism had that sort of humanitarian background which a lot of people had never thought of as being part of it."[17]

Through her own work and Man Ray's contacts, Lee began establishing her own career in Paris. She did her own creative work, photographed her own clients as well as taking on commercial work that Man Ray increasingly passed to her. Even though they were no longer living together and Lee had her own studio in Montparnasse, Man was still very much present and increasingly distraught over Lee's independence. Her many love affairs, most notably with the New York art dealer, Julien Levy, whose gallery would show her first one person exhibition in 1933, and Aziz Eloui Bey, the charming and cultivated Egyptian she had met through her friend Tanja, were more than he could bear.

Lee's restlessness and desire for new experiences compounded by Man Ray's jealous resentment finally prompted her to leave Paris and him behind. She returned to New York and along with her brother, Erik, opened her own photography studio near Times Square in 1932. With her innate talent for involving others in her projects and the backing of a couple of wealthy friends, she opened Lee Miller Studios and it became immediately successful in spite of the financial havoc of the Great Depression in the wake of the Wall Street Crash three years earlier. As her friend Tanja said later about Lee's portraiture work in New York City, she was "THE photographer to be photographed by."[18] Working as a portrait photographer was the principal professional avenue open to women photographers in the 1920s and 1930s, and Lee had the ability to take the conventionally beautiful photographs so valued by

the cultural elite. She had learned the use of ramatic lighting and the straightforward manner of the best photographers of the period, as in her own *Self-Portrait*. In other portraits, her Surrealistic eye is unmistakable and harkens back to her earlier work in Paris. Her portrait of *Joseph Cornell* captured the inner dream-world of the shy and reserved artist as well as evoking one of his magical boxes with their collaged layers of yearning, mystery, and otherworldliness. Lee also continued her fashion photography and her technically precise and elegant commercial advertising work along with her portrait commissions. Her commercial and "art" work might seem contradictory, but in fact other Surrealist artists were doing the same. Man Ray continued his work for the fashion magazine *Harper's Bazaar* during the 1930s

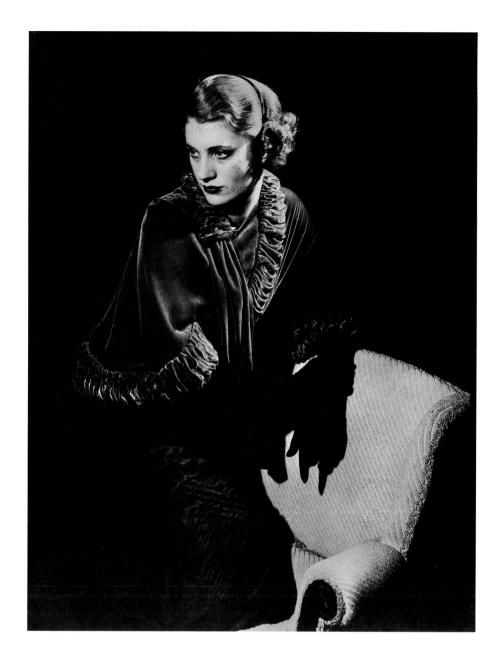

while Salvador Dalí worked on several Surrealistic fashion projects which included advertising and window displays. In fact, the top fashion magazines of the period featured the new avant-garde as a marketing strategy and Surrealist paintings were often used in fashion photo-shoots.[19] Hollywood was not immune to the excitement generated around the movement and Max Ernst and Man Ray later worked there as well. Surrealism united art, popular culture, and commerce much like Pop Art was to do years later on an even more comprehensive scale.

Lee Miller
Joseph Cornell, NYC Studio, New York
1933

Lee Miller
Self-portrait, NYC Studio, New York
1932

Aziz Eloui Bey arrived in New York in 1934 and he and Lee resumed their love affair. Sixteen years older than Lee, he was nurturing without being over-bearing and Lee felt she had met someone she could be herself with and who would care for her. Lee introduced him to her parents one weekend and called her mother later to ask if they had liked him. When her mother responded affirmatively, she replied that was good, as she had married him that morning, July 19, 1934, in City Hall. They married again under Muslim law at the Royal Egyptian Consulate. Lee left for her new life in Egypt and abandoned her broth-er Erik to dismantle the studio. He too was newly married and left in the lurch by her sudden decision, but later he was offered employment in one of Aziz's businesses and joined her in Cairo in 1937.

Once there, besides the constant social life of cocktail parties, bridge, and golf, Lee enrolled in a chemistry course at the American University, studied Arabic, and began documenting her new surroundings. Lee continued exploring the photographic medium, taking pictures of the unusual rounded formations left by hundreds of thousands of pigeons bred for manure, bursting sacks of cotton, and the stylized forms of the sand drifts and ripples. Some-times she photographed the absence of presence, as in *Shadow of the Pyramid of Giza*, where we question which is more real, the object itself or the shadow it casts. "Why are certain photographs that do not seem Surrealist actually

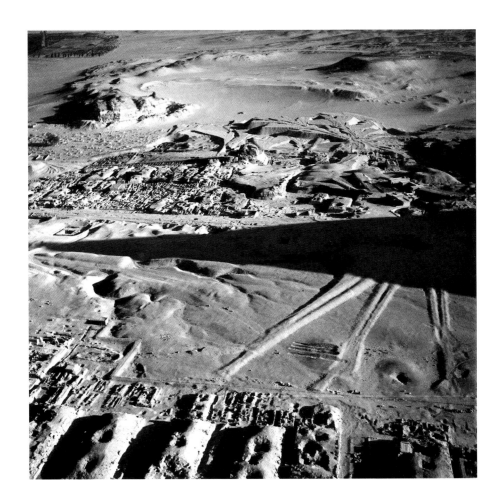

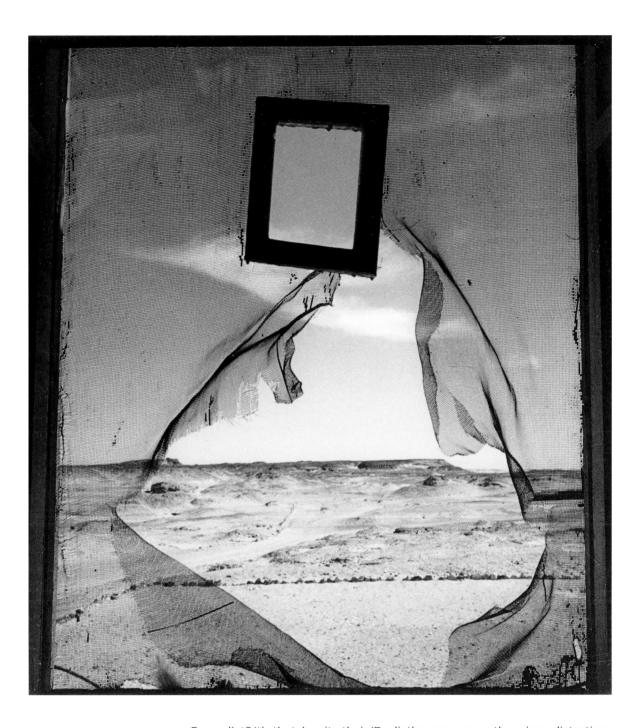

Lee Miller
*Shadow of the
Pyramid of Giza,
Egypt.*
1938

Lee Miller
*Portrait of Space,
near Siwa, Egypt*
1937

Surrealist? It's that despite their 'Realist' appearance—there is no distortion
or other technical experimentation—they resolutely reveal the uncertain. The
transformations, the losses of substance reveal that there is nothing stranger
than the familiar: all that is needed is a suitably trained gaze."[20] In this
version of her pyramid shadow shots, there is a rich graphic quality with multiple
shades and nuances of gray, creating texture patterns similar to those made
by frottage.

Unlike many of the Surrealists who rarely photographed landscapes,
Miller used the desert, its strange natural formations and austere architectural
structures in what was literally an alien land. It served as the perfect metaphor

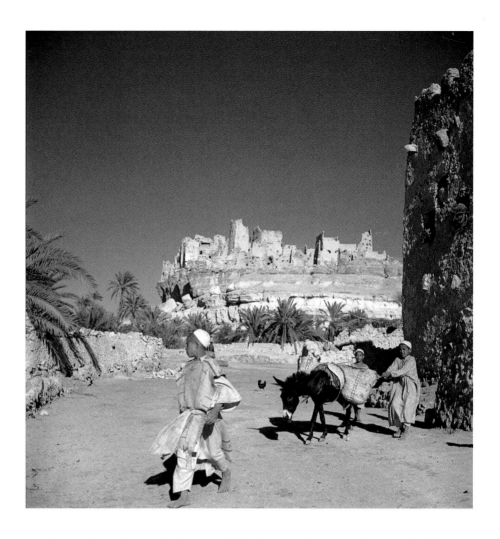

for exploring dreamlike themes of displacement: perhaps the empty vistas were an inner portrait of Lee and the vacuous, confining lifestyle she felt she was living in Egypt removed from the stimulating worlds of Paris, London, and New York City. Many of her barren, stark images taken there are reminiscent of Surrealist paintings by Tanguy, de Chirico, and Dalí. In one of her most intriguing images, *Portrait of Space*, we see the duality of bursting out into the vast space through the hole in the netting, not unlike Alice in Wonderland discovering a strange new world, and at the same time, being shut into a small barren room viewing wispy clouds through the small window of a prisoner's cell. In the photograph *Children and Donkey, Siwa*, the image is richly layered with information. In the composition, the village emerges out of the sand; Lee aptly called them anthills. It is that same sense of isolation of a small community that Roland reflected in his painting *Egypt*. As Whitney Chadwick said about this period in her work: "Miller's visualization of space took a more abstract form. Her photographs from this period reveal a feeling for the disquieting image, a strong awareness of formal relationships in nature, and an ability to capture in black and white the abstract qualities of objects bleached by the powerful desert sun or rendered artificial by intense contrasts of light and dark. The desert provided a physical and psychological escape for Miller

Lee Miller
Children and Donkey, Siwa, Egypt
1939

36

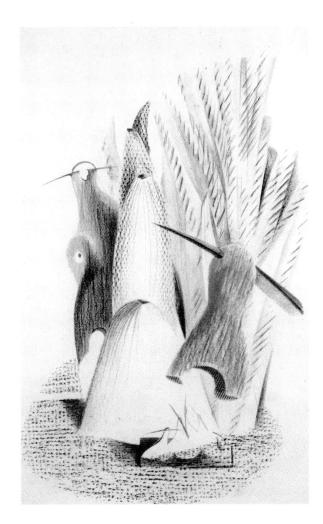

Roland Penrose
Egypt
1929
Pencil and chalk
frottage and pencil
on paper
48 × 31 cm
Collection of Douglas
and Vibeke Bergeron

Lee Miller
Pigeon Guano Farm, Egypt
(detail)
c. 1935–39

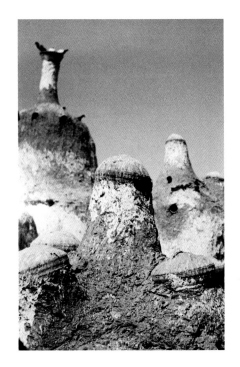

who, camera in hand, pursued in nature a vision formulated during her years with Man Ray and one unrestricted by social convention."[21] Likewise, there is a strong resonance and shared aesthetic between Roland's pencil-and-chalk frottage, *Egypt*, with its textured conical structures, and the earthen formations in *Pigeon Guano Farm*. In both images, the rounded, phallic figures are punctuated by enticing circular openings. These mysterious, organic structures, from the dream world of the unconscious, hint at a strange new land.

Lee was restless once again. The constraining social norms among the well-to-do expatriate community in Cairo provided a much too sedate and predictable lifestyle for her. Aziz, realizing her frustration and boredom, surprised her with a ticket to Paris to break the monotony of her Egyptian lifestyle. The day Lee arrived in France, Julien Levy invited her to a party that was being given that evening. As Roland was to describe in his autobiography, *Scrap Book*, Lee's life at that time in Cairo surrounded by "duck-shooting men and highly conventional ladies dressed in black satin and pearls was not to her taste so she had come back to Paris for the summer, independent and eager to renew her life in less orthodox company."[22]

And that she did. It was there, exactly one year after that first auspicious meeting with Lee's lips in the painting that Roland met *the real woman* a name he gave to one of his richly layered mixed-media collages later that summer. As Roland described in their first meeting: "It was in a fancy-dress ball, organised by the Surrealists at the house of the Rochas, the dressmaking people in Paris. A very gay affair indeed and everybody went dressed up in the most weird and extraordinary style. Max Ernst took me there and he said, 'We must go, and we are going to dress up as beggars.' We certainly did. We were the most revolting couple you ever saw among these very elegant people in very fancy costumes. There was one girl who was not dressed up at all. She just had a long evening dress on, and that was Lee Miller who I met for the first time that evening...."[23] Completely smitten by the most beautiful woman he had ever seen, he asked Max about her, and they arranged a dinner with her and mutual friends the following evening. Lee and Roland fell head over heels and were inseparable for the rest of that summer, first in Paris, and then in England, amongst the green meadows, the shaded woodlands, and the intimate coves of Cornwall. Roland had rented his brother Beacus's house

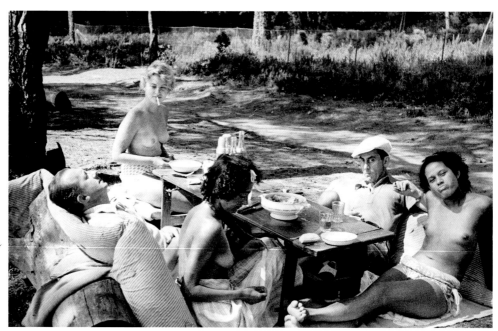

Roland Penrose
Picnic with Nusch and Paul Eluard, Lee Miller, Man Ray, and Ady Fidelin, Mougins, France
1937

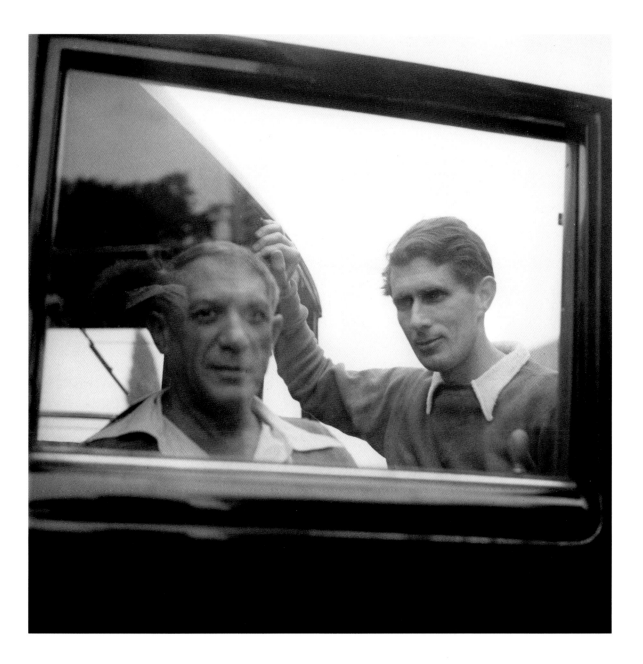

for the month of July, and in that protected and secluded corner invited all to come. Lee, who too often had been used as a kind of inspirational object, was seduced by Roland's gentlemanly and elegant intelligence and admiration. As for Roland, intelligence and character as well as beauty were things, as he said, he found "dominating" in women.[24] It was a *coup de foudre* for them both and they embraced their passion for each other and for that moment in life with Surrealistic zeal. In his biography, Roland described that first idyllic summer in the company of their Surrealist friends, Max Ernst and Leonora Carrington, Nusch and Paul Eluard, Man Ray, and Ady Fidelin. One of the landmark photographs of Surrealists at play, *Picnic, Mougins*, was taken at the pinnacle of their glorious summer together, with a lesser-known version (left) in which Roland holds the camera. Their house party was augmented by other artists and friends, Henry and Irina Moore, Eileen Agar, and Joseph Bard.

Lee Miller
Picasso and Roland Penrose, Mougins, France
1937

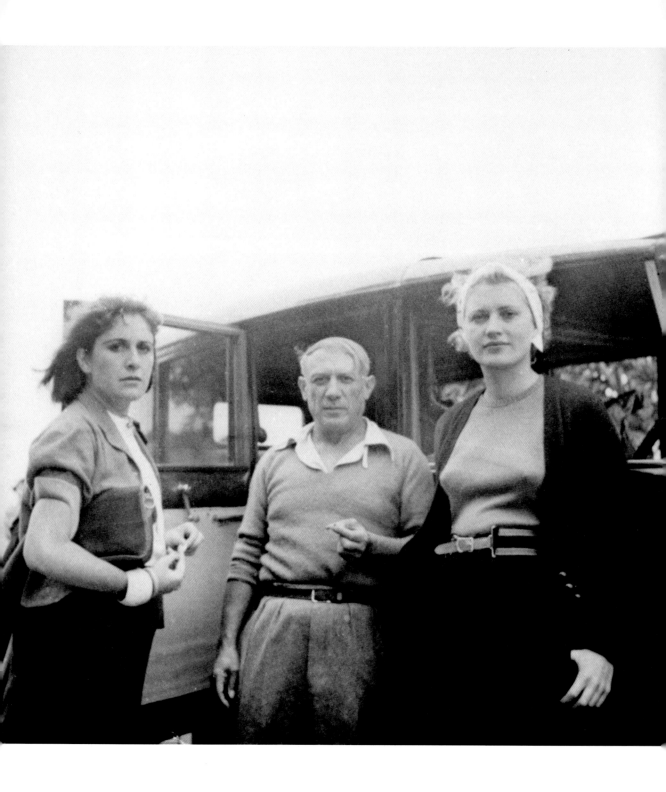

Roland Penrose, *Dora Maar, Picasso, and Lee Miller,* 1937

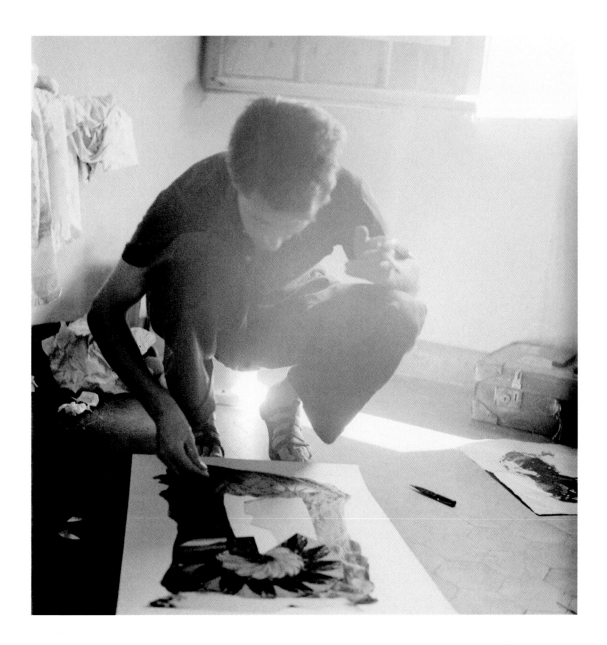

At the end of July in England everyone parted company only to reunite later on that summer in France. On the drive south, Roland and Lee stopped and visited the painters Paul Delvaux and René Magritte in Belgium. The entire house party from Cornwall moved to the southern coast of France where Picasso and Dora Maar were once again staying at the Hotel Vaste Horizon in Mougins, a beautiful town in the hills above the sandy beaches of Cannes. Here the group of friends enjoyed days of frolicking in the sea on the Côte d'Azur, good food and wine, and good-natured and ever-changing love trysts as they worked and played in equal measures.

It was here in Mougins that Picasso painted six portraits of Lee as L'Arlésienne, his penetrating gaze capturing the slightly green tint in Lee's blonde hair as he worked that summer. It was a productive period for Roland as well. He began making collages with postcards combined with the other techniques of decalcomania, frottage, and drawing. It was a way of working

41

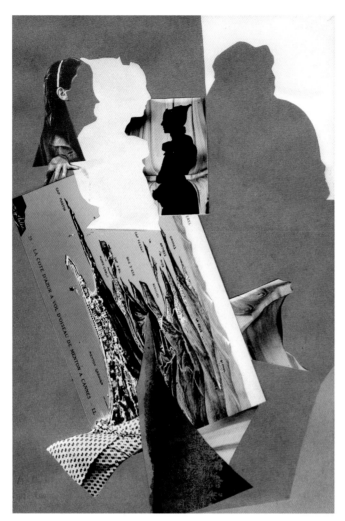

which he would go back to throughout the rest of his life. As he described it: "Attracted by the vivid color of the picture postcards on sale everywhere, I began to experiment with them in collage. Sometimes I found that repetition clusters could take the effect of a spread of feathers or a simple image cut out and set at a peculiar angle could transform completely its original meaning."[25] The repetitive shapes of sand ripples that both Lee and Roland photographed appear in several of the collages. Lee also experimented with making collages that summer, combining her own photographs with other techniques, shapes, and forms to create positive and negative spaces. Her work is smaller in scale than Roland's and she was never to return to it as a medium. That summer it was one more way she and Roland explored and shared their discovery of each other.

At summer's end, the time came for Lee to depart for Egypt. In her first letter to Roland en route to Marseille to catch the ship back home, she expressed her anguish at leaving:

> It's cold on the train—I'm alone with the noise, and my tears, unlike your chains bind me—it was true—it is true—I'm leaving—I love you and I'll return.[26]

Their correspondence became the vital life-line that kept their romance alive, and her letter to Roland the next day expressed her deep regrets at going back to a life and a husband that were no longer in the forefront of her thoughts:

> Darling, DARLING, darling, darling, darling. ... I linger over all the syllables that I can invent in it—it is the only thing I can think or say.... I touch all my treasures.... I must destroy something—myself—you—or our memories—I can't bear this for long—I almost doubt that there were three months so perfect—so happy—maybe I invented it too....[27]

Lee Miller
Untitled
*(Eileen Agar and
Dora Maar)*
1937
Collage
24.5 × 17 cm
A. & R. Penrose

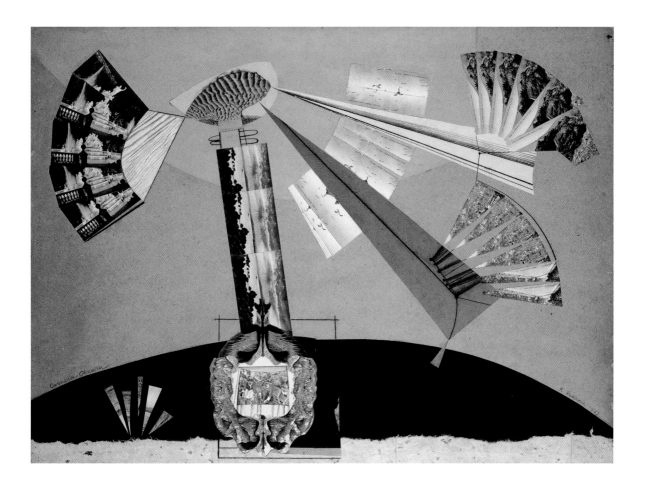

Roland kept up his correspondence, describing his life, his temporary loves in her absence, Surrealist activities, and the ever-growing collection "that collected itself", which included some of the key artworks from the first half of the 20th century. For Penrose, it was a very fertile, inspired period in his art production. *Camera Obscura*, a mixed-media collage, is one of his most intriguing images, with its elegant, balanced ochers and blues and strong sense of movement. The collage includes a photographic fragment of sand drifts taken by Lee. The carousel is turning on an axle, suspended by a phallic lighthouse made by decalcomania, and its beams reach out, searching, while anchored on a black sphere. It is also a camera obscura, pulling images into a small room to be contemplated, enjoyed and relived, away from the surrounding external world. Roland's use of different techniques in this piece is exemplary, as is the color and kinetic rhythm created by the repetition of elements.

Roland's flow of beautiful pale-blue letters sums up his feelings at the time:

Roland Penrose
Camera Obscura
1937
Collage
75.7 × 101.2 cm
Private collection

My love, I'm back here where I started from — stacks of fatuous un-answered letters, pictures, objects and an intolerable silence, a blank, everything tries to look as though nothing had happened and to hide the fact that all has changed, that a marvellous presence has been here and has gone. — Darling I read your letters, I'm broken — a wreck, only

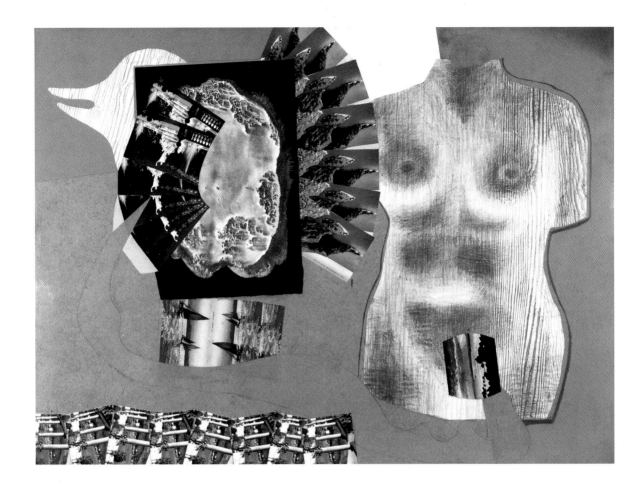

three words in it give me courage and something to live for, three words
written in the train. Darling if they are true all is well, you say 'I'll return'.
Oh my love without that I can see no way out of this hell. To have lived
three months of such unbelievable happiness lost in the enchantment
of your presence and for it to finish like this is unbearable. I see you,
hear your voice, feel your hand every minute and its nothing — gone —

... I can never say how much I love you; it is beyond all powers of
expression. You have given me something new, something so potent
that it is either life or death. Darling I want you. Darling come back.[28]

Roland also discussed in detail pressing world events; he was very concerned
with the developments in the Spanish Civil War, even more so since his friend-
ship with Picasso. He continued to describe to Lee the exhibitions he visited
in Paris and London, the publication of Man Ray's new book in December, 1937,
and the opening of the Exposition Internationale du Surréalisme in Paris in
1938 with over three thousand people in attendance at the opening. *Real
Woman* was exhibited, showing Lee's torso in frottage and a quirky bird's head
in profile (perhaps a play on Roland's pet name for Lee, "duck") that peers off
into the distance. There were other exciting exhibitions that followed in 1939,
"Surreal" objects from indigenous cultures that fascinated Breton, as well as

Mexican popular art exhibited next to Frida Kahlo's paintings. Roland also talked about his feelings to Lee and his yearning for her:

> …you have changed me much more than I could have ever changed you
> —you started me on a life so much fuller, so much more wonderful than
> anything I had known, in a way which I thought in these days impossible
> for me and now you my love, my darling, the heart of it all are gone….

He did find temporary solace, however, and was very open and frank about his sexual partners in her absence. In the same letter, he went on to describe the other woman who occupied her bed until she could resume her place there:

> Actually darling most people would think that I had forgotten you already,
> your bed has not been empty for the last four nights but Thea who
> occupies it is so different that I almost feel ashamed to make love with
> her. She is very sweet and is perhaps the only person who could console
> me of this bitterness. She puts up with my gloom with great patience
> though I talk of you whenever I can and tell her of the lump that I can't
> move at the bottom of my heart.[29]

Unknown
photographer
*Exposition
Internationale du
Surréalisme, Paris*
(Penrose's collage
Real Woman
is on the wall)
1938

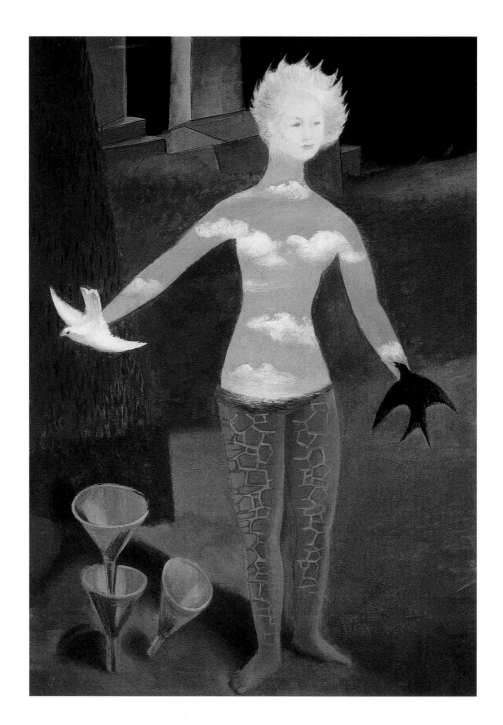

Roland Penrose
Night and Day
1937
Oil on canvas
49.5 × 34 cm
A. & R. Penrose

Roland Penrose
*Abstract Composition
(Portrait of
Lee Miller)*
1946
Oil on canvas
74.5 × 50.2 cm
A. & R. Penrose

Lee's reaction is extraordinary for a woman who has just fallen deeply in love. Perhaps it is here, more than anywhere else, that she showed she had internalized the Surrealists' thoughts and behaviors regarding sexuality:

I think you should keep a series of cuties in so you will never be quite alone. Incidentally cutie is right, though I find Q. T. better, as it means in Yankee slang 'on the sly'.... It's very nice that Thea is with you — I liked her very much... I hope you are as tender with her as you know how to be — because if she likes me and is replacing me, especially so soon, it's as if she were me — and I could feel it.[30]

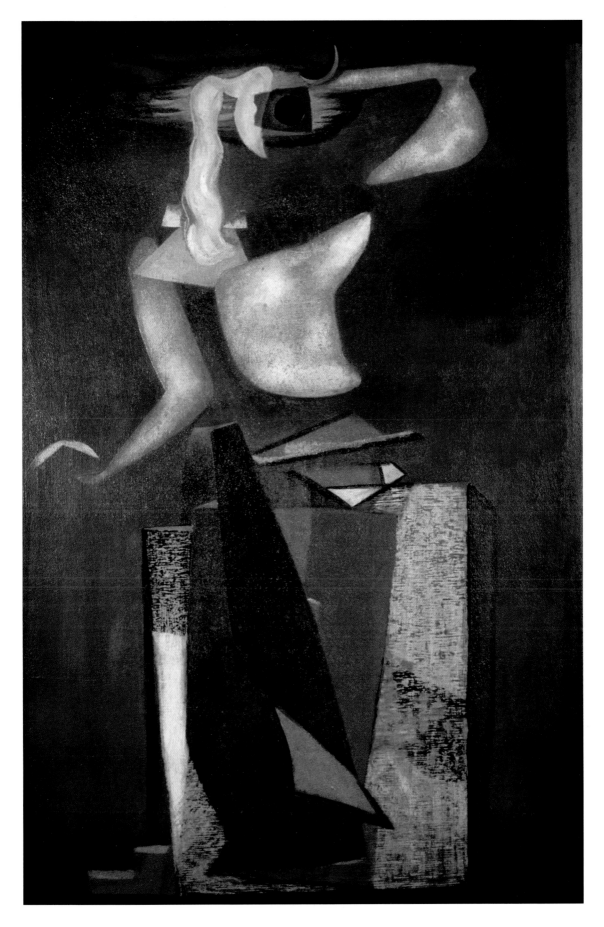

Roland continued his passionate correspondence to Lee as she settled back into her life in Cairo and began taking more and more photographic expeditions into the desert. The steady flow of mail assured her of his devotion. They had discovered a hidden piece of themselves in each other and their passion for art and for a life lived fully arose from that bond:

> I long for you physically, but I also long for you in lots of other ways —
> your way of seeing things when we are out together is a thing I miss all
> the time, your way of making every moment we spent together new and
> significant, your abandon, your affection and your sense of humour.[31]

Roland transformed his yearning into painting and Lee became, from then on, the muse that informed and inhabited his paintings for the rest of his life. In one of his letters to her, he described what he imagined she might have looked like for a Cairo society costume ball Lee was attending. That image was to manifest itself almost verbatim in his painting *Night and Day*:

> I imagine you nearly naked with probably bricks painted all up your legs,
> moss growing on the tops of these towers, a serene blue sky for your body
> with two cotton white clouds as your breasts, two black pigeons as your
> hands and the sun itself as your face.[32]

The symbolism in this painting and its companion piece, *Abstract Composition (Portrait of Lee Miller)* is fascinating on many different levels, with its Magritte clouds, the positive and negative play between the swallow, bearer of spring and visitor from Egypt, and the white dove. Lee's head is not only backlit this time by the golden rays, but a representation of the sun itself. The four elements are there in balance; and receding in the dark background to the right of the composition, are the two pyramids of Giza in the distance. The second version, from 1946, painted just after her return from the war, show the same elements in turmoil, fractured, floating, broken apart.

In response to his letter, Roland received Lee's letter of longing and her feeling that she was imprisoned in a life isolated from the world and the person she most yearned for:

> I wish that I were to see the house all stuffed with treasures, overflowing
> with new pictures,[33] and overflowing with me too. MY God I'm so bored
> here! I think that I am slowly going mad. I can't even kid myself into
> patience with the three weeks less before I'm to see you. It's already a
> lifetime. When I think that the same length of time was what I spent in
> Cornwall[34] and it seemed already my entire life changed, glowing and
> renewed. That those three weeks were all I hoped for at that time.
> Forever. My darling, my fingers stumble so much when I write you — my
> heart falters and stumbles when I think of you — I'm blind — and I wait

only for another blue letter to match my breakfast china to read in bed
in the morning — to warm against my body while I close my eyes and
dream again and feel again.[35]

The following summer Roland travelled to Athens to meet Lee and they ex-
plored, photographed, and travelled together across the Balkans from Athens
to Bucharest. That trip was documented in the exquisite visual poem/artist's
book that Roland wrote for Lee, *The Road is Wider than Long*. In this multimedia
work, all of Roland's sensitivity and artistic force come into play and he com-
bines photographs, drawing, and frottage with his handwritten text in different
colored inks. It is his deeply personal account of their voyage together and it
is imbued with her presence:

> Lovers who escape, who are free to separate
> free to re-unite leave their tongues
> plaited together hidden in the dry grass
> folded in peasant made cloth
> embalmed in the green memories of desire

In her correspondence to Roland, Lee explained that she and her husband Aziz
were openly discussing her relationship with Roland. It reflects, as do earlier
letters Aziz wrote to Lee's parents, the paternalistic way Aziz saw her and his
genuine concern for her well-being:

> Aziz and I had long conversations about you and my situation in general.
> The result is that I'm going on this trip then come back and see what
> everything is about. He doesn't want to divorce me unless he is sure
> that I am going to be happy and taken care of elsewhere. I told him that
> I'd had enough of marriage for the moment and didn't want to marry
> you until I had at least sufficient adjustment to make up my mind and
> that you had a very nice character and seemingly a great deal of love
> and patience and willingness to not let me get into trouble. Is all that
> still so? So maybe I'll come to London to live about the middle of Decem-
> ber, or go to Switzerland with him for two months and see if there isn't
> any way that we can mend our troubles before splitting up permanently.[36]

pp. 50–53

Roland Penrose
*The Road is Wider
Than Long,*
pages 39–42
1937
Original manuscript
Each page 20 × 15 cm
A. & R. Penrose

Roland visited Egypt in early 1939 and that summer Lee joined him in France
where they visited Dora Maar and Picasso as well as Leonora Carrington and
Max Ernst. At the end of the summer, Lee informed Aziz that she had decided
to stay and moved in with Roland in the Hampstead neighborhood of London.
He continued actively to work at his own painting. Roland made a portrait of
Lee entitled *Egypt,* based on the ancient tomb murals of the goddess of the
sky, Nut, with her elongated body separating the cosmos from chaos, her
arched body enveloping an Egyptian village, set in the distance against a sky

Lovers who escape, who are free to separate
free to re-unite leave their tongues
plaited together hidden in the dry gras
folded in peasant made cloth
embalmed in the green memories of desire

LEAVE YOUR TONGUE

STUCK to the bark

She must twist her hair round the branches

This will avoid all danger
of not meeting next year

Then the journeys alone that fill

the world become fertile

in each tower on each headland

as the frontier is passed lovers

watching for the red train

have grown into each other's eyes

the colour of their hope is

the white feather of a volcano the blue eye

which opens in the clouds before sunset

the stage of a greek theatre echoing

the smile that drops from her lips

like bats they make love by day
their heads buried in the stones
their feet searching for lions in the hills

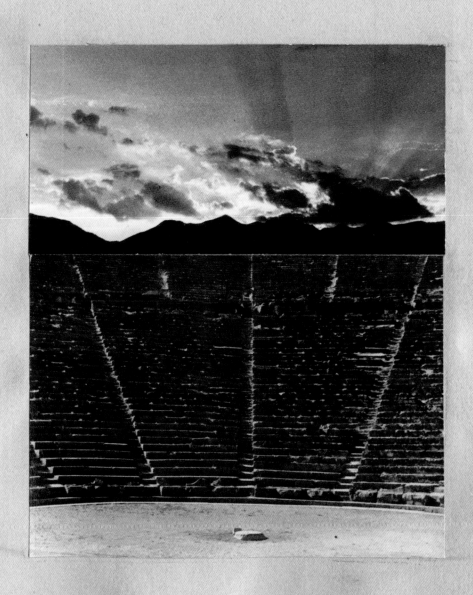

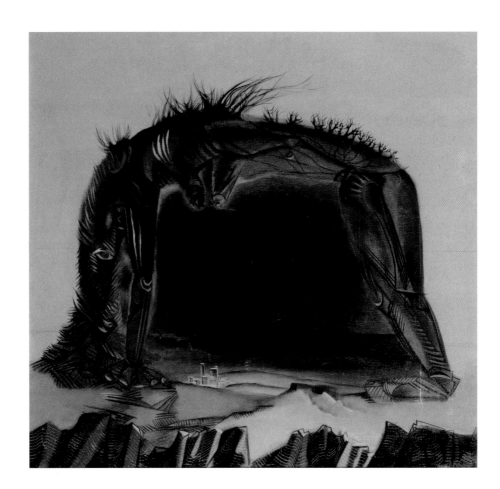

of deep Miró-like yellow. The setting aludes to Lee's desert excursions and photographs. The webbed hands, sprouting roots, and the enveloping arched body are reminiscent of Max Ernst paintings, *La Belle Saison* as well as *The Horse, He's Sick*.

The following year, Roland submitted an oil painting to the Royal Academy for the United Artists' Exhibition. The painting, an abstract portrait covered in handwriting, was rejected on the grounds that there were certain words in its composition which were considered unseemly: it ends with "His thighs windmills, His sex flex, His arse his arse, His heart anything, His head nothing". His wonderful sense of irony and humor created an appropriate response when he sent an alternative painting of glove stretchers, which as four sets of hands spelled an even more unseemly word in sign language (S.H.I.T.). That painting was accepted and exhibited in spite of a deaf employee, beside himself with laughter, pointing out what it said.

Roland Penrose
Egypt
1939
Oil on canvas
62.3 × 74.4 cm
A. & R. Penrose

War

During the pounding and disorienting months of the Blitz with hundreds of bombs being dropped on London each night, Lee led a Surrealistic and schizophrenic life between her job as fashion photographer for British *Vogue* magazine and, in her own time, photographing the destruction left by the nightly bombing. The world was suddenly turned upside down and her Surrealist eye was the perfect tool for making sense of the madness of war. Much like her earlier work in Paris, Lee adapted the Surrealist technique of the *objet trouvé* (found object) to the photographic realm and used the *image trouvée* to explore the streets of London. Her choice of objects, scenes, and events were sardonic juxtapositions of the transformed reality of life in unreal circumstances. Her highly developed sense of humor and razor-sharp irony is

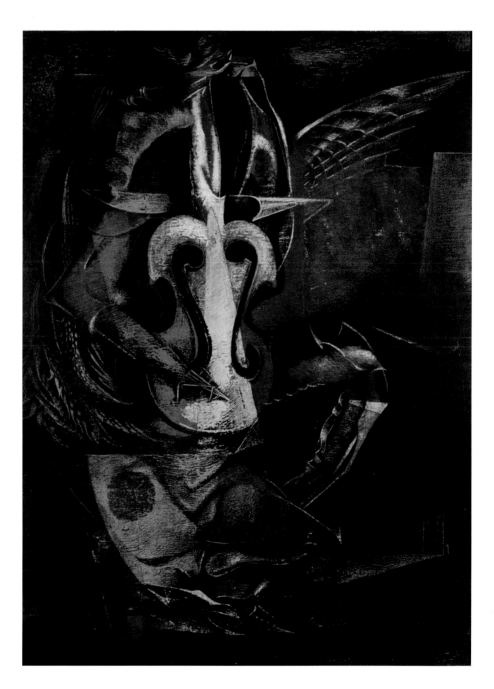

Roland Penrose
Black Music
1940
Oil on board
59.5 × 44.7 cm
A. & R. Penrose

revealed in both the composition and subject matter of her photographs. Lee's vision was one in which typewriters were silenced permanently and church-goers were converted into stone blocks pouring out of the church. Instead of a rousing sermon, they had a resounding bombing. Antony Penrose describes his mother's work from this period that was published in the book entitled *Grim Glory: Pictures of Britain Under Fire*: "Her eye was Surrealist and poetic, seeing in each image a statement that could be interpreted at many levels. Superficially the picture titled *Remington Silent* may be of a bashed-up type-writer; subliminally the shattered machine taps out an eloquent essay about the war's assault on culture. The simplest shots are often the most eloquent; they are the photographs carrying a truth that cannot be articulated in any other way. In these images anger burns deep."[37]

At the same time, Roland worked on a series of very dark canvases. In *Black Music*, the violin is transformed into a skull-like mask of death with knives emerging from the neck of the instrument. The wings in the background sym-bolize the planes overhead, and the triangular flash is slashing searchlight beams, then a glaring explosion in the instant a bomb shattered the city during those very dark nights. The whole series he painted during that period was musical in theme. Similar to the newsreel broadcasts preceding films in Ameri-can cinemas, they described the nightly onslaught as a symphony orchestra

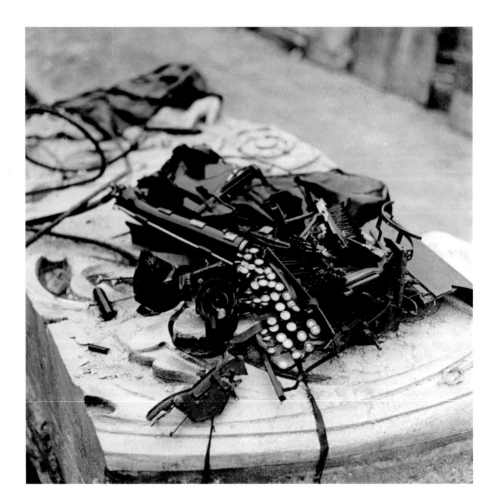

Lee Miller
Remington Silent, London
1940

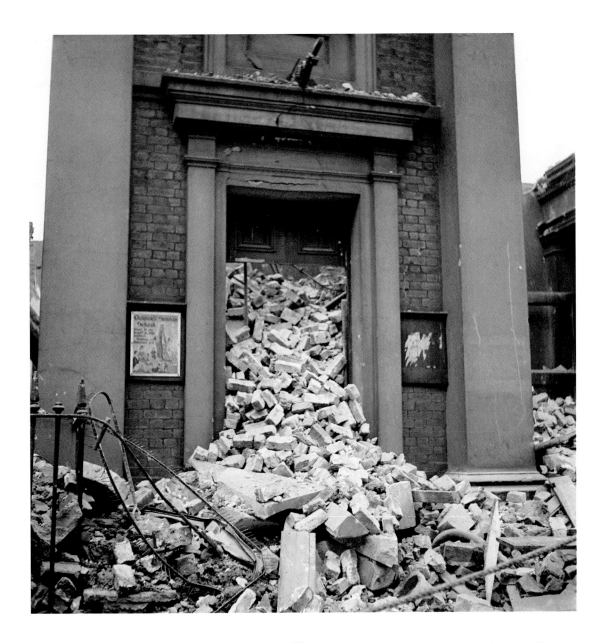

with the music of bombs.[38] Roland described his thoughts at the time: "It was the noise of the bombardment at night. It was so overwhelming I felt it was the relentless work of demons, so to make them less terrifying I tried to see them as a group of musicians. They seemed less threatening that way. The art of primitive man always seemed to me to have been doing just that — converting hideous intangible fears into art that might still frighten us, but we can see it and touch it so it becomes more understandable".[39] During the Blitz, he worked as an air-raid warden by night and painted by day. He then went on to write a manual on camouflage which, while practical, is also delightfully illustrated with his insightful studies into nature's ability to disappear in the right context, as in the case of a zebra who disappears or not depending on the directions of the stripes in the background. As a result of his publication and his lecturing, Roland was recruited by the army as a camouflage instructor with the rank of Captain and was put in charge of the Eastern Command

School of Camouflage in Norwich. His two worlds — the War and Surrealism — intersected and converged once again, as he tested some of his more alluring camouflage methods on Lee's naked body, arguing that if he could hide her seductive charms, he could hide anything. Showing images of Lee in his lectures had the added advantage of ensuring the full attention of the troops.

Meanwhile, as world events unfurled in an even darker downward spiral, Lee was feeling frustrated by her comparatively superficial fashion work. She met a young American *Life* photographer, David E. Scherman, and he quickly became part of the household at Downshire Hill. It was already bursting at the seams with assorted friends, Roland's ex-wife Valentine, and Lee's stray tabby cats, Jeep and Taxi, all of whom had been displaced by the bombing and had taken refuge in Roland's Hampstead home. At Dave Scherman's prompting, Lee became an accredited war correspondent with the US Army and went into Normandy soon after D-Day. Nine years his senior, Lee teamed up with Scherman and as partners they established a close personal and professional relationship. Together they covered the allied advance, photographing key events as they unfolded. It is these poignant and tragic images that are the sublime documents of Lee's heritage and also those that were to leave her soul wounded by the horrors of war. As Antony Penrose has said about his mother's preparation for the mad juxtaposition of destruction on top of life:

David E. Scherman
Lee Miller in Camouflage, London
1942

58

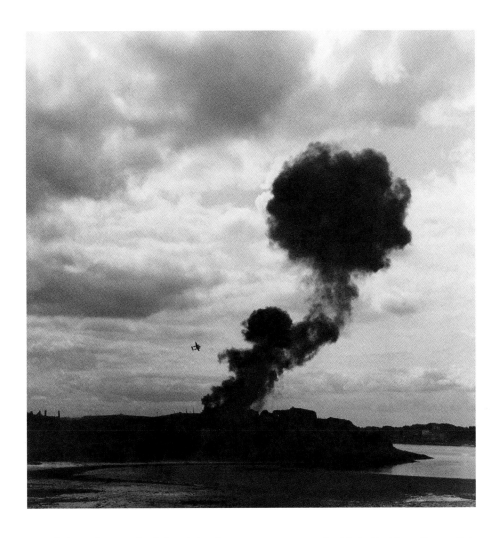

"The only meaningful training for a war correspondent is to first be a Surrealist —then nothing in life is too unusual."[40] Lee followed the troops, and as the only known female photojournalist to photograph direct combat with the infantry, she was there for the siege of Saint-Malo and photographed the first use of napalm by the US Army at St. Lo in Normandy in 1944. The British Army suppressed the film and Lee was almost court-marshalled for exceeding the limits of her accreditation. She continued on through France and arrived in time for the Liberation of Paris. The first thing she did was go directly to Picasso's studio to see how he had survived the occupation. There she was reunited with Roland, who had taken leave to be there, as well as their close Surrealist friends. Lee, now permanently dressed in her Army uniform, was bizarrely and surreally assigned to cover the Paris fashions after the Nazi occupation. Outraged at being criticized by the editor of American *Vogue* for the lack of elegance in the fashion settings and the models, Lee sent back a cable explaining that the photographs had been taken under the most rudimentary of circumstances and reminded her that there was a war on.[41] Before leaving Paris to follow the US troops across Europe, Lee photographed the writer Colette now aged seventy-one in her apartment and described the encounter in *Vogue*: "Her voice was gruff but her hand had been warm and

Lee Miller
Napalm Strike
on the Citadel,
Saint-Malo, France
1944

59

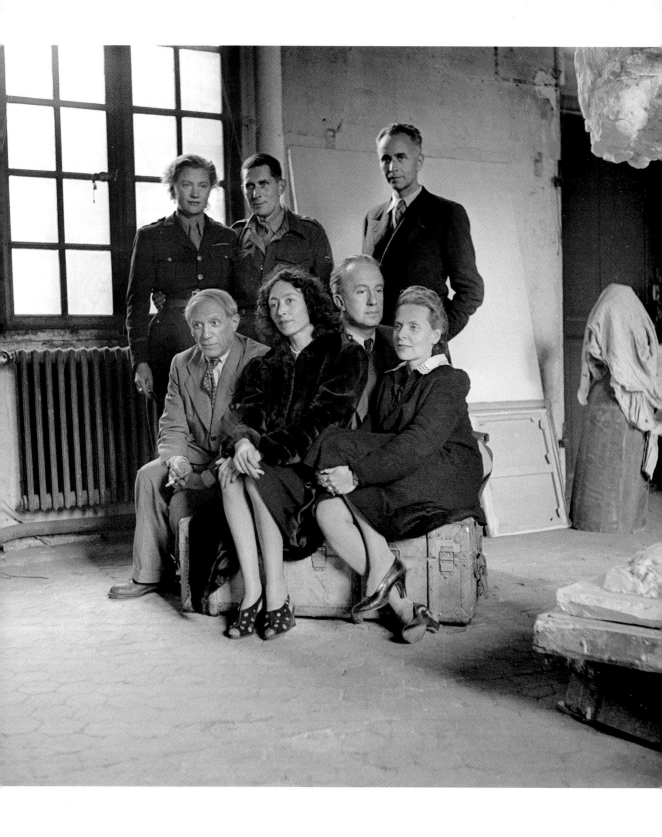

Lee Miller, *Group Photograph (after the Liberation of Paris)*
L to R standing: Lee Miller, Roland Penrose, and Louis Aragon; sitting: Picasso, Nusch Eluard,
Paul Eluard, and Elsa Triolet. Picasso's Studio, Rue des Grands Augustins, Paris, 1944

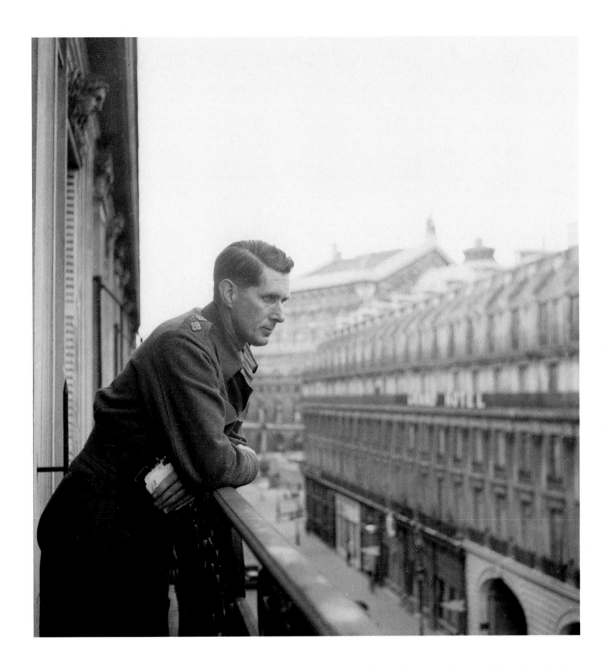

her kohl-rimmed eyes matched in sparkle and clarity the myriads of crystal balls and glass bibelots which strewed the room."[42] Miller also photographed those who came to perform for the troops, among them the dapper Fred Astaire, an amusing Bob Hope, and the glamorously dressed Marlene Dietrich in a new Schiaparelli gown.

Miller carried on across the country to Luxembourg where she witnessed the terrible destruction the small country had been subjected to. From there she met up with "her boys", the 83rd Division, friends since Saint-Malo, and spent her thirty-eighth birthday at the momentous meeting between the Russian and American allies in Torgau, Germany, where the two armies made contact for the first time during the war. She moved on again through the numbing cold with the Allied troops as they stoically continued through Alsace in eastern France. They were Americans, French, Moroccans, Argentinians,

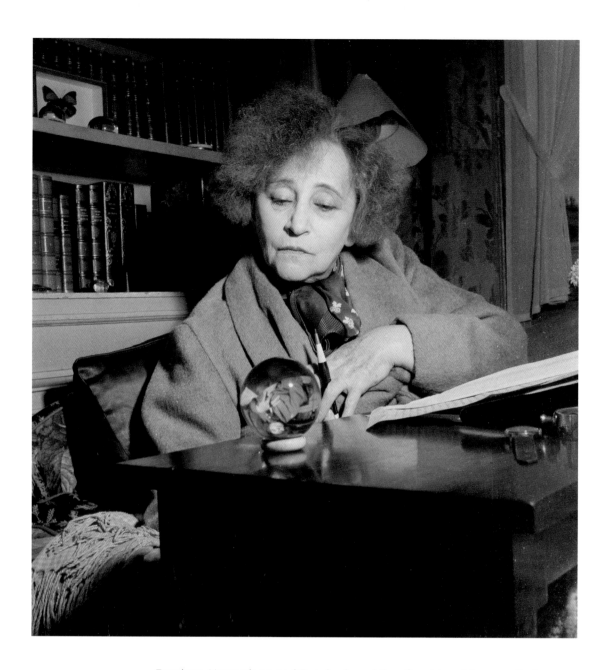

Russians, Hungarians, and Spaniards and they fought and froze on their move towards Germany during some of the most vicious encounters of the whole war.

Lee's shocking photographs from the liberation of the Buchenwald and Dachau concentration camps and her articulate and impassioned writing during the darkest moment of the 20th century still serve as a warning of the fragility of human life and the extreme abuses that take place within the context of war. Her impassioned plea, "*I implore you to believe this is true*" clearly influenced the editors of *Vogue* magazine who, remarkably for a highly sophisticated fashion magazine, published her graphic photographs of the camps along with her detailed description of what she saw as she visited them: "Dachau had everything you'll ever hear or close your ears to about a concentration camp. The great dusty spaces that had been trampled by so many thousands of condemned feet — feet which ached and shuffled and

Lee Miller
Colette, Paris
1944

David E. Scherman, *Lee Miller, Weimar, Germany*, 1945

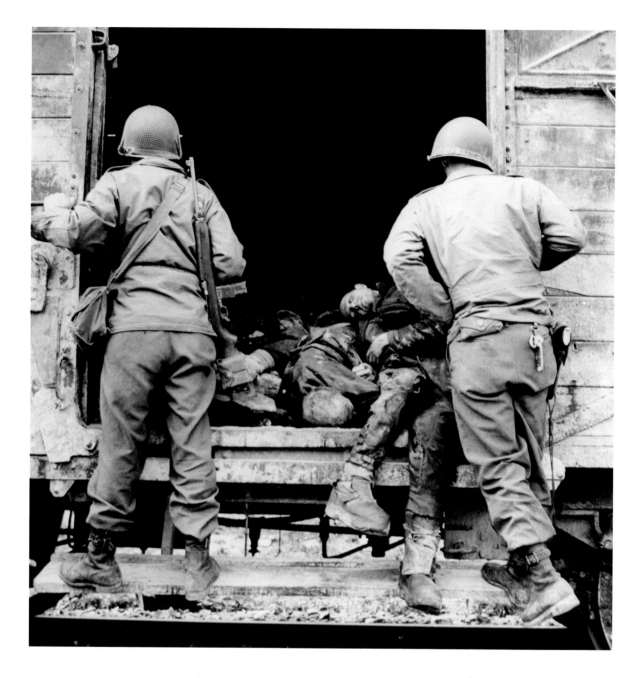

Lee Miller
US Soldiers examine
a Rail Truck Load
of Dead Prisoners,
Dachau, Germany
1945

stamped away the cold and shifted to relieve the pain and finally became
useless except to walk them to the death chamber."[43]

There is an excruciating and almost lyrical beauty in some of her images,
as in *Relaeased Prisoner, Buchenwald, Germany*, in which the legs of a Nazi
prisoner stand posed as if preparing for a ballet of death with "toe shoes"
made of layered, mended socks to keep from freezing in the bitter German
winter. As Lee and Dave Scherman advanced into the city along with the troops,
they ended up sleeping in Hitler's recently abandoned house in Munich, visited
Eva Braun's villa the next day, and photographed his Wachenfeld retreat at
Berchtesgaden in flames just days before Germany's surrender. Throughout
Germany, she photographed buildings reminiscent of her Constructivist im-
ages from 1930 but instead of a balanced geometry of structure she showed

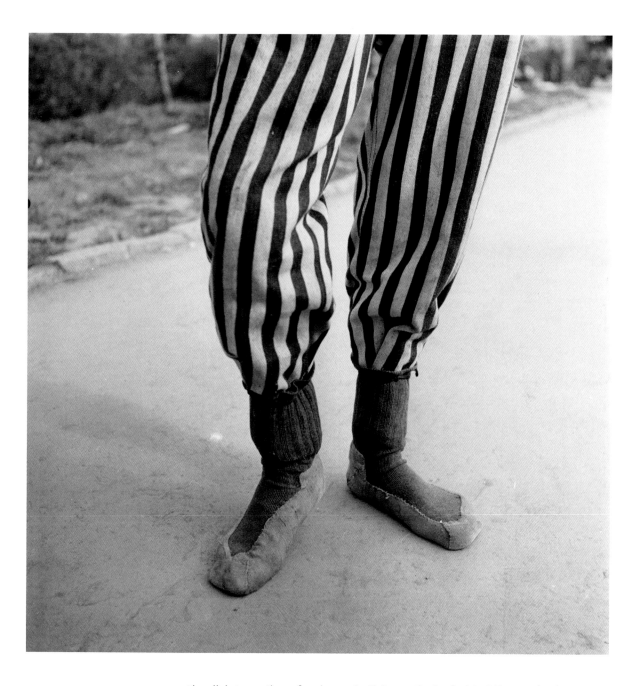

the disintegration of order, as in *Cologne Cathedral*. In *Liberated Prisoners with Human Remains, Buchenwald*, the piled human bones at the feet of prisoners echo an even more horrific and terrifying cry of destruction than the cathedral's rubble. Her outrage and irony is expressed in these images, and like all her field work, they were taken on a Rolleiflex camera with no modern-day telephoto lens or zoom to distance her physically from the horror and depravity of the war-torn world she inhabited. She continued to travel deeper and deeper into Europe and fell further and further into depression, with little or no relief.

Lee Miller
Released Prisoner,
Buchenwald,
Germany
1945

Lee Miller, *Cologne Cathedral, Germany*, 1945

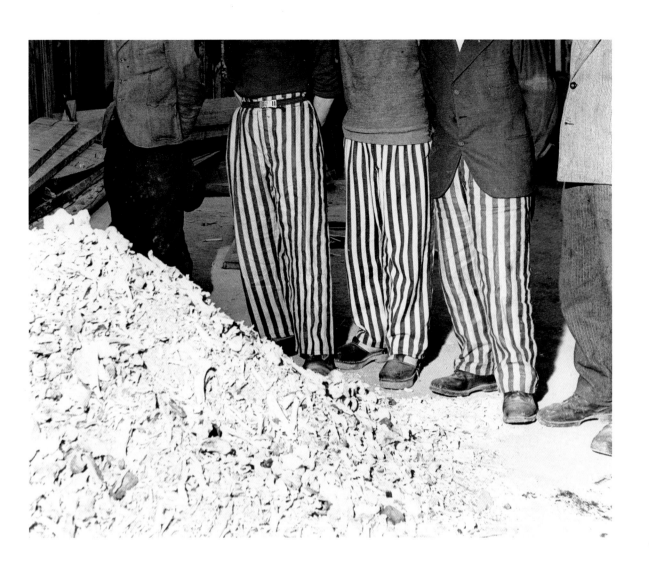

Lee Miller, *Liberated Prisoners with Human Remains*, *Buchenwald, Germany*, 1945

Postwar—Redefining Moments

After leaving Germany, Lee was still driven by her anger and a need to record what was happening, and so she continued on, this time without her faithful comrade, Dave Scherman, at her side. She covered the news in Eastern Europe, the children dying in a Viennese hospital underlining the bitterness of her own disillusionment at the failure of the war to deliver a fair and just world she had believed everyone was fighting for. In Hungary she witnessed the firing squad execution of the Prime Minister; and then she moved on to Romania.

Once the initial victory celebrations were over, the postwar period presented an excruciatingly grim and desperate image. An article in *Life* magazine from winter 1945 summed it up:

> The first winter of peace holds Europe in a deathly grip of cold, hunger and hopelessness. In the words of the London Sunday *Observer*: 'Europe is threatened by a catastrophe this winter which has no precedent since the Black Death of 1348.'
>
> These are still more than 25,000,000 homeless people milling about Europe. In Warsaw nearly 1,000,000 live in holes in the ground. Six million buildings were destroyed in Russia. Rumania has her worst drought of 50 years, and in Greece fuel supplies are terribly low because the Nazis, during their occupation, decimated the forests. In Italy the wheat harvest, which was a meager 3,450,000 tons in 1944, fell to an unendurable 1,304,000 tons in 1945. In France, food consumption per day averages 1,800 calories as compared with 3,000 calories in the U.S.
>
> Germany is sinking even below the level of the countries she victimized. The German people are still better clothed than most of Europe because during the war they took the best of Europe's clothing. But their food supply is below subsistence level. In the American zone they beg for the privilege of scraping U.S. army garbage cans. Infant mortality is already so high that a Berlin Quaker, quoted in the British press, predicted, "No child born in Germany in 1945 will survive. Only half the children aged less than 3 years will survive.[44]

Roland had once again kept up his steady flow of letters to Lee, but months had gone by since she had responded to him or anyone else. Roland finally gave her an ultimatum in an attempt to get a response and salvage their relationship:

> Darling,
> For so long I have tried to understand your silence. A silence which not only touches me deeply but, so I'm told affects your dealings with your office, your parents and Aziz...have wanted to know for so long what you were doing and thinking, but no clue to that has come through. I still hope it will. You might even arrive out of the clouds at any moment—but I am not prone to believe in ghosts and you darling, by your own behaviour

68

have become a ghost. Whether I like it or not you have made yourself no more, no less. My cables, my letters remain unanswered and I am worried — then tired of having a phantom.

Our pact, our pact made from the whole bottom of my heart was one which gave you always your liberty. Every hour spent with you was an hour of supreme happiness — every hour without you was just too bad. But now these hours without you have taken big proportions and there is no sign that the future will be any better — how do you wonder that my hopes, my fancy should not stray, as indeed yours must most certainly have done also.

Darling Lee, I ask you for an immediate reply — cable me as soon as you get this — what are you doing, when are you coming home? My reasons for asking are vital. You asked me before leaving if I had some girl I loved as well as you — now I have. Someone you don't know — have never seen and who is here — real — no ghost.

This is my last appeal — not as a poem this time but with all the love and devotion to you that you know — I hope — so well.

In the spirit of that understanding we had together from the start and which if kept by us both is the only true understanding, do, my Lee, answer what has happened to you and what are your feelings about the future. I don't love by halves and I don't hate those who I have loved but I must know to whom my loyalty is due — if you refuse to answer I shall take your silence to be your reply.

But should you answer, my darling, you can put to rest, in your own terms, this heartache which is all due to the immense love that you have kept alight in me for so long.

Lee — my darling — answer Roland.[45]

During Lee's seven months of silence, she had written long letters to Roland, it is just that she never mailed them. In the grips of a depression it was all she could do to keep moving. In one of the unmailed letters, she explained her sense of futility and confusion and anguish with everything — herself, post-war Europe and the future:

Darling Roland,
I haven't forgotten you. Every evening when I could take the time and certainly have the interest to write you I think that tomorrow I'll know the ultimate answer or that my depression will have lifted, or my exaltation ebbed or whatever — so that I'll be able to write you a more coherent impression containing some sort of decision — whether it be that I'm staying or coming home, licked. That moment never comes...

When the invasion occurred — the impact of the decision itself was a tremendous release — all my energy and all my prefabricated opinions

were unleashed together; I worked well and consistently and I hope convincingly as well as honestly. Now I'm suffering from a sort of verbal impotence — when there was a necessity for stopping being afraid (like you know how cowardly I was during the blitz) I could and did. This is a new and disillusioning world. Peace with a world of crooks who have no honour, no integrity and no shame is not what anyone fought for…I saw the guys who were grey or bloody or black. The boys who were white with anger or green with fatigue and sometimes shook because they were afraid, I was awfully sorry that the war wasn't for anything at all — and I was very angry.

Really great groups of humans are suffering the same shock symptoms caused by peace that I'm combating — and I don't in the least mean the boys going back home to find that they've become dependent upon a benevolent maternal army — that they have outgrown their wives or become socially unfit or drunks or misanthropes. It's just an impatience with the sordid dirt which is being slung around now compared with the comparative cleanliness and the real nobility of helping to win the war — and the people who bought bonds so that their disreputable government could continue after the war loan had been paid off … A more disorganized, dissolute and dishonest population has never existed in the history books.

The room and my affairs are a hopeless mess and I'm incapable of sorting them out; however they hang over me and depress me all the time. Paul doesn't answer his phone, nor Picasso, nor Dora … I'm leaving for this Austrian trip tomorrow morning, Saturday, at dawn with a great deal of dread and boredom. Davie is hanging round waiting for me to get off because he knows that if he doesn't, I'll never leave.

Love,
Lee….[46]

Dave Scherman, her work partner, wartime lover, and best friend, then back in New York and informed of what was going on, sent a two-word cable to Lee which simply said, "Go home."

Lee finally headed back to England, exhausted and disillusioned by the postwar power struggles and the devastation left by the war. A text carved in stone on a monument in Paris written by Miller's old friend, the Surrealist poet and writer Louis Aragon, could have been about her: "Celui qui croyait en Dieu celui qui n'y croyait pas tous les deux aimaient la belle prisonnière des soldats" [The one who believed in God, the one who didn't believe, both of them loved the beautiful prisoner of the soldiers].[47] While physically she was only briefly held prisoner under house arrest twice during the war, emotionally and psychologically she was imprisoned by it for the rest of her life.

Roland's image of stripped trees in a cemetery in Romania (see p. 73) are strangely similar to the shot that Lee took several years later of the US Hospital tents in Normandy. Even more prophetic are the words he wrote to accompany the photograph of a dead peasant girl and how they evoke the changes that were apparent in Lee after the trauma of the war:

> but should you try to come back
> you will suffer more than us
> the ropes that bind you are strong
> the horse will lead us to your grave
> the tree that dies with you
> will be torn down
> your heart will be filled with knives.

The woman who had taken Lee's place at Downshire Hill left quietly. Lee and Roland, both changed by the war and their long separation, worked to re-establish their relationship. The following year, they travelled together to the United States where they visited their close friends Max Ernst and Dorothea Tanning in Arizona, Man Ray and his future wife Juliet Browner, and Lee's younger brother Erik and his wife Mafy in California. Roland's painting of Lee, *Unsleeping Beauty*, comes from this time as does the later version of *Night and Day* where the figure is breaking apart. Her body is sliced into pieces and fragmented and it has a sense of displaced time with an ambiguous sliver of the moon on a dark hill below a flat Tanguyian yellow sky. The looming figures, painted in the primary colors of the Hopi Kachina dolls so beloved by Ernst, Breton, Duchamp, and the other Surrealists, stand as sentinels in the background, suspended in the nether world. The central figure appears again in another painting by Penrose entitled, *The Dutchess*, perhaps referring to Dutchess County where Lee was born and raised.

While on their coast-to-coast trip in the US, Roland was particularly interested in gathering information on art institutions such as the Museum of Modern Art in New York, with an eye to creating something of equal importance in London. Lee took advantage of the trip as well and made portraits of the sculptor Isamu Noguchi, whom she had first met years before when studying at the Art Students' League, the painter Wifredo Lam, and the composer Igor Stravinsky.

Lee continued to work for *Vogue* as a fashion photographer. It was unsettling to be back in that world after everything she had been through and the irony of that comes through in some of her images such as her photograph *Fashion Shot, Sicily*, a *faux* action shot reminiscent of the real airfields that Lee had been in during the war, an almost cinematic version of a scene from her earlier life.

In 1946, while on location in Switzerland for a *Vogue* commission, Lee discovered she was pregnant. She and Roland married the following May and

Lee Miller, *Tent Hospital, Normandy, France,* 1944

Roland Penrose, *The Road is Wider Than Long,* page 32, 1937
Original manuscript, 20 × 15 cm, A. & R. Penrose

but should you try to come back

you will suffer more than us

the ropes that bind you are strong.

the horse will lead us to your grave

the tree that dies with you

will be torn down

your heart will be filled with knives.

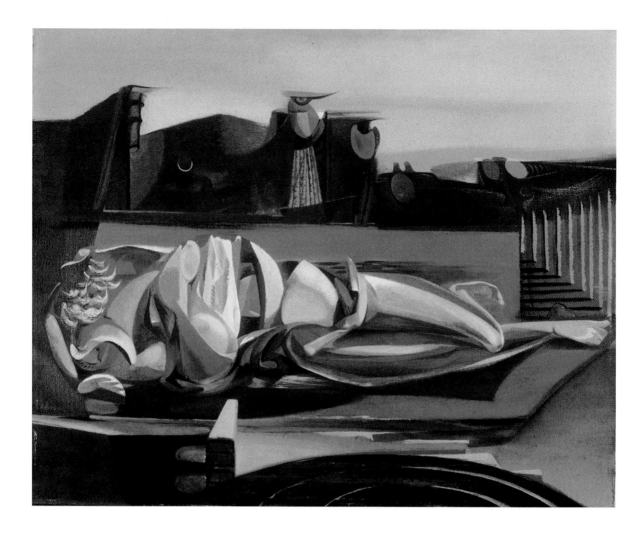

in September 1947, their son Antony was born. At the age of thirty-nine, Lee began that new adventure in her life. Sadly, besides being a mother and adapting to all the changes that entailed, Lee was now falling further into a downward spiral of depression and alcohol abuse. Her melancholy and sadness is reflected in a portrait that Roland painted of her at that time, his vibrant pinks and blues forming a contrast to the sense of troubled conflict in her expression.

The effects of postwar trauma in the 1940s were rarely dealt with in any genre with a few notable exceptions, one being the film *Best Days of Our Lives* by William Wyler released in 1946. It looked critically at the military, and graphically depicted the sense of dislocation, the futility, and the alcohol abuse that physically and emotionally maimed veterans were faced with when returning from active duty. But while the military gradually put in place mechanisms to deal with post-traumatic stress disorder and other pathologies, the same traumas lived by frontline journalists were ignored. It is only recently that trained psychiatrists have studied the effects of war on journalists and discovered that thirty percent develop serious symptoms that need treatment. Of these, the photographers' proximity to danger increased the symptoms and physical ill health in general. These circumstances, combined with the

Roland Penrose
Unsleeping Beauty
1946
Oil on canvas
58×74 cm
Private collection

Lee Miller
Fashion shot, Sicily
1949

taboos associated with their lack of "toughness" and the delayed symptoms which emerged months later, made diagnosis in Lee's era inexistent. Relief came in the form of self-medication. That was most readily accessible in the form of alcohol which led to it being used in excess to dampen down the guilt and stress.[48] Much of this is reflected in Roland's portraits of Lee from that period: her postwar stress, the collapse of a totally engaging career, her anxiety at being a mother, and her unhappiness at not finding a suitable

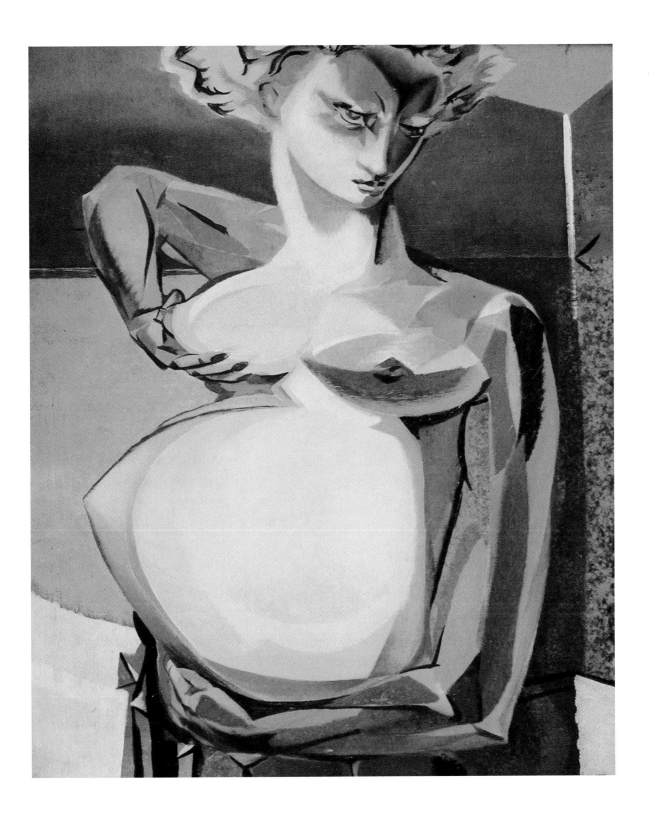

Unknown photographer
Lee Miller and Roland Penrose with Painting, "First View", 36 Downshire Hill, London, 1947

Roland Penrose, *Lee Miller, Pregnant Portrait,* 1947
Oil on canvas, 72 × 59 cm, A. & R. Penrose

solution to any of it. *The Flight of Time* revisits an earlier, happier period through the iconography of the two birds in Lee's hands in *Night and Day*, but this time there is no joy. The order of the birds is reversed and she is troubled by the almost dead bird of peace which is slumped and depleted in her left hand and the aggressive black bird of war, which has become a projectile that is aimed and ready to attack again and again. Lee's halo of golden hair is still backlit, like the early photos Roland made of her that first summer in Cornwall. But in this image, the light has gone out of her face, replaced by a wounded melancholy and leaving only the distant green memories of desire. *King Harry Ferry*, a delicate yet masterful watercolor also from around this time, is another throwback to earlier times and the Cornish coast. It shows a half-submerged woman reflecting the other half in the water; she is no longer complete. It is a theme that Dalí too was to develop in his drawing, *Paranoiac Face*, the contours of the head and body becoming part of the geography of the place.

Roland too was at a crossroads of a different nature. He realized he needed to make conscious choices once the war was over. He was faced with the dilemma of either resuming the life he so loved as a painter, or abandoning it to work at promoting the art and artists he so strongly believed in. *Don't You Hate Having Two Heads?* has a visual strength with its twisted internal organs in contrast to the hard coat of armor on the outside:

Roland Penrose
The Flight of Time
1949
Oil on canvas
39.4 × 49.5 cm
A. & R. Penrose

The war disrupted the way in which I had hoped to develop, and even before the war it had occurred to me I would never attain the stature in the arts of my brilliant surrealist friends...whose genius made the first decades of the twentieth century a period of unusual brilliance. I realized that one of the most valid activities I had embarked on with some success was the encouragement of others to understand and enjoy all that I had found most worthwhile for myself. I felt an urge to bring about a wider appreciation of the poets and painters who had inspired me. Although I continued to paint and make collages on similar lines to those that had interested surrealists before the war, in future the pen was to take precedence over the paintbrush as a means of expression and I was to join company with friends in London and Paris in an effort to make the arts more accessible, more appreciated and more an integral part of life.[49]

Roland Renrose
King Harry Ferry
c. 1949
Watercolor
25.5 × 34.2 cm
Private collection

Roland had begun laying the groundwork for the Institute of Contemporary Arts (ICA) on their return from the US, and his dream of a platform for presenting the artists and the work he so strongly believed in started taking shape. The first exhibition, "Forty Years of Modern Art", took place on borrowed premises in 1948. One of the pieces in the show, Picasso's *Les Demoiselles*

d'Avignon, was too large to fit through the door of the borrowed exhibition hall, the Academy Cinema in Oxford Street. The dilemma was solved by making a huge hole in a wall backing on to a bombed site and squeezing the painting through.

Unknown photographer
Ewan Phillips and Roland Penrose at the ICA hanging Picasso's "Les Demoiselles d'Avignon"
1948

Roland Penrose, *Don't You Hate Having Two Heads?* *(self-portrait)*, 1949
Oil on canvas. 99×71.3 cm, A. & R. Penrose

With the end of the war, Lee had put the boxes of her life, or the lives that she had lived up until then, into the attic at Farley Farm. She was an innate archivist so along with all of the memorabilia she had collected along the way she packed up and stored her manuscripts and over 60,000 negatives and prints of her photographs. Once stashed away, they were wilfully ignored and then entirely forgotten as if trying symbolically to bury the deep wounds the war had left within her. *Breakfast*, a portrait of Lee in a seemingly peaceful domestic setting at breakfast, shows her distant and inaccessible. Her body has become a black negative space hidden behind the barrier of a newspaper; once again the only remnant from her earlier joyful portraits is the halo of blonde hair, still tied with the ribbon she was wearing in the Cornwall photographs from the summer they met. *Surrealist Composition*, a more structurally complex painting, is one of the few portraits of Lee and Roland together. Lee's face has been taken over by a third eye, as in another painting, *The Eye of the Storm*, and it has once again created a distance between her and the world, much like viewing the world through a camera. The hard geometric lines in the structure emphasize the distance between the two, the male figure's African, mask-like face cautiously attempting to bridge the distance. Lee's hand has metamorphosed into a bird, and she has a pair of vertical lips between her breasts, the sharp angles of her body creating a sort of protective armor.

In spite of each of them sacrificing a part of themselves, Lee and Roland worked to create a home together that became a fusion of their love of art and a sanctuary for their friends who were scattered across the globe. They

Roland Penrose
Surrealist Composition
1950
Oil on canvas
48.3 × 59.7 cm
Bolton Art Museum,
Lancashire

Roland Penrose
Breakfast
1949
Oil on canvas
52.8 × 43 cm
A. & R. Penrose

embarked on a rural Sussex lifestyle after years of endless travelling, and became twin magnets that drew the world to them in Chiddingly, Muddles Green. Their lives were still punctuated by frequent forays into the greater cultural world, but with their son Antony in the loving hands of his nanny Patsy Murray, they enjoyed the flexibility of movement they had always had.

In 1950, the ICA opened its own space in London near Piccadilly. Roland had been involved in every step of its development and had been actively creating an interest in it by giving lectures and organizing exhibitions on other premises for the two years it was being structured.

Lee created a more informal series of photographs in the 1950s, more casual in conception, yet equally professional with her unerring eye for composition. As she often remarked, you cannot be an amateur after having once been a professional. In this series, which was published in *Vogue* under the title of *Working Guests*, with text and images by Lee, she portrayed the famous visitors who came to Farley Farm performing a series of household chores. Her sense of humor still strongly in place, she had the founding director of the Museum of Modern Art in New York feeding slop to the pigs, and the brilliant cartoonist and illustrator Saul Steinberg "drawing" the ancient Neolithic figure of The Long Man of Wilmington on the Sussex Downs behind him. Lee's other images from this period reflect a domestic lifestyle in which she photographed her son Antony with Picasso as his playmate, her husband Roland

Lee Miller
*Saul Steinberg,
East Sussex, England*
1953

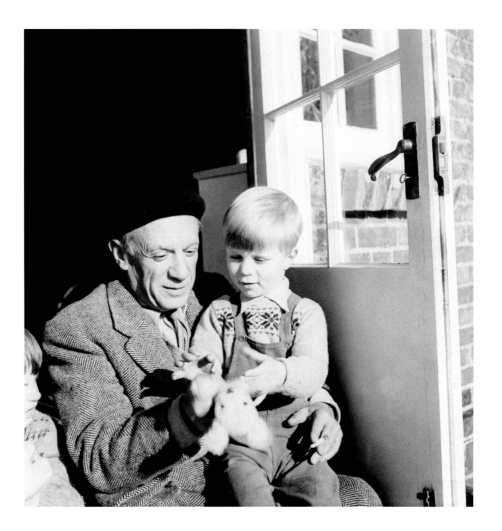

working in his studio, her father Theodore's visits to England, and life on the farm where they lived.

Never one to throw herself lightly into any endeavor, Lee became a driven and talented gourmet cook, specializing in Surrealist-style dishes. As a child, she had delighted in mixing ingredients in her chemistry set, and had later studied chemistry during her first year in Egypt. Even more importantly, the chemistry of cooking combined with the alchemy of chance was not unlike her time in the darkroom where she worked with precision, focus, and concentration until she got the results she wanted. It was creative, she made exuberant platters of visual and culinary delights, and her skill as a hostess complemented Roland's work as a diplomat in the art world.

In 1955, Roland was approached with the project of writing a biography on Picasso. As he explained years later in an interview:

Immediately after the war I got back (to Paris) and again our friendship grew, but I suppose it would have never become so intimate if I had not, to my great surprise, been asked by Gollancz to write a definitive life of Picasso...the first thing I thought was I will go and see Picasso and ask him what he thinks, which I did. I found him in the sea, at Collioure,

swimming around, so I swam out to him. I said 'Well, what do you think—
somebody like me who has never written a book before in his life, and
really hardly knows how to spell and they want me to write a book about
you. Do you think I could do it?' Picasso said, 'Well I suppose there have
been literally hundreds of books written about me. People have said
what they thought. Why don't you do the same thing and say what you
think? I went and lived near him—I can't say I ever interviewed him. One
day I went to lunch there and there was just Jacqueline and himself at
lunch, very friendly as usual. Jacqueline said to me 'Now is your time.
We are all alone at lunch together; ask him all the questions you want.'
I said, 'Well, I find it very difficult to ask questions like that indeed, in fact
I might easily ask the wrong question.' To which Picasso said, 'Yes, if you
ask the wrong question, I shall give you the wrong answer.'[50]

Their lives, while settled in many ways, were still fraught with turbulence.
Lee had travelled to New York for her parent's fiftieth wedding anniversary
and remained there until after the death of her mother. Roland explained in a
letter to Alfred Barr, the director of the Museum of Modern Art, that he was
waiting for her to return to embark on a major research trip for the Picasso
biography.[51] Roland relied on Lee's unerring eye and her social skills and he

Lee Miller
*Roland Penrose
and Picasso with
an edition of
"Portrait of Picasso,"
La Californie, Cannes,
France*
1957

respected her intelligence and instincts so it seemed only logical that he consider her an essential part of his new undertaking. In spite of her alcoholism, when it was under control, Lee was still fun and engaging and brought a spontaneity to what could otherwise be a forced situation. Lee was in need of a stimulating project and what better one than to reconnect with Picasso and what he represented—her happier prewar days. Roland and Lee had started out their lives together travelling and so it seemed like a good antidote to the tensions in their relationship caused by Roland's significant affair with Diane Deriaz. Diane had been very much present in Roland's life since their meeting in 1947; Lee had first accepted her and then only tolerated her presence, as it became increasingly apparent that she was not a passing fancy.

Penrose not only asked the right questions for the Picasso biography which was received with great critical acclaim, but published a total of twelve books on different aspects of the artist's work, many of which went on to be

republished a number of times. Roland's books generally contained photo-
graphs by Lee, who photographed over a thousand images of Picasso during
the thirty-six years of their friendship. During these academically fertile years
for Roland, he also wrote books on Joan Miró and Antoni Tàpies, monographs
on postwar sculpture and catalogue essays on Max Ernst, Francis Bacon, and
others. The ICA continued to evolve and change; in 1968, it moved to much
larger premises on the Mall.

A photograph Lee took of her son Antony was included in Steichen's
1955 landmark exhibition at the Museum of Modern Art, "The Family of Man",
to celebrate the universality of human life and emotions. She continued her
masterful portraiture, characterized by her directness and an eye for originality,
creating a rich legacy of many of the key personalities of the century. Among
those she photographed in these postwar years are the painters Miró, Moran-
di, Dubuffet, Wifredo Lam, Matta, Oskar Kokoschka, Jean Arp, and Richard
Hamilton as well as the writers Dylan Thomas, Stephen Spender, and T. S.
Eliot. In 1973, Lee and Roland travelled to Barcelona where she photographed
Antoni Tàpies working in his studio for Roland Penrose's upcoming publication
on the Catalan artist. Roland and Lee remained close to Man Ray, and in tribute

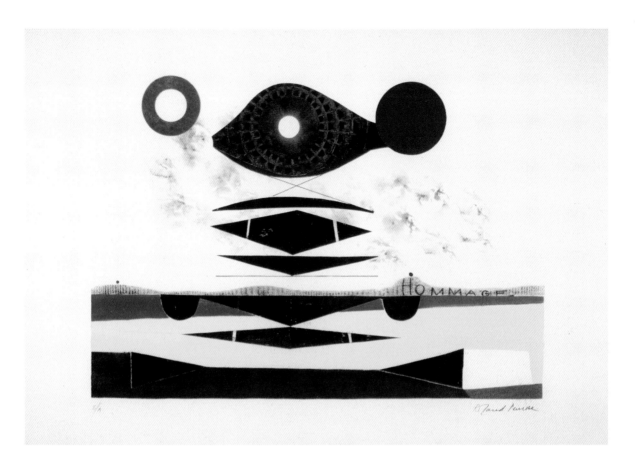

to his elegant and all-seeing eye Roland made a lithograph in primary colors and a geometry of forms balanced on the letters of Man Ray's name arranged on the bellows of a folding camera. At the same time, it is a tribute to Picabia's 1915 pen-and-ink drawing of another folding camera entitled, *Ici, c'est ici Stieglitz*.

In 1976, a body of Lee's work was bought by an enlightened and far-sighted curator at the Art Institute of Chicago. She also found some peace towards the end of her life, and she and her son, Antony, were able to meet at last as equals and as adults, and establish a short but fruitful relationship. She died of cancer at home in England in 1977 surrounded by her family. Roland told their son that in all the years they had been together, they had never been unfaithful to each other. Antony was astonished, having personally met a number of the many liaisons they both had. Roland went on to explain that at the beginning they had agreed they were free to sleep with whomever they wished, but their love for each other was to remain forever sacred.[52] In 1980 Roland wrote his autobiography, *Scrap Book*, which is peppered with photographs of and by Lee, and that same year he accepted the post as Honorary President of the ICA.

Roland Penrose
Hommage à Man Ray
1975
Lithograph
34.8 × 50 cm
A. & R. Penrose

Full Circle: Back to the Beginning

After a stroke had left Roland unable to write, Diane Deriaz, who had been in and out of his life for thirty years, encouraged Roland to go back to his work in collage. At the end of his life, Roland came back to Lee's lips one last time. They had shown up before, over the years, both horizontally and vertically, and had been present in *The Flight of Time* and several other paintings. It was no surprise that they were there again, floating alone in the sky while three white fairy terns flew towards the heavens. It was to be his final art piece, aptly entitled *The Last One*.

The connection was still there in spite of Lee's absence. Their lives had intersected, overlapped, run parallel, diverged, and found a way of reconnecting again through it all. Their union had been a meeting of minds, of two bodies and souls, and together they had survived improbable odds. Their skill in the art of life and their commitment to a life devoted to art was intrinsic to their enduring relationship. The synchronicity they had shared in so many ways held true one last time, and so it was that Roland Penrose died at Farley Farm in 1984 on April 23, Lee Miller's birthday.

Roland Penrose,
The Last One
(Seychelles)
1984
Collage
46×60.9 cm
A. & R. Penrose

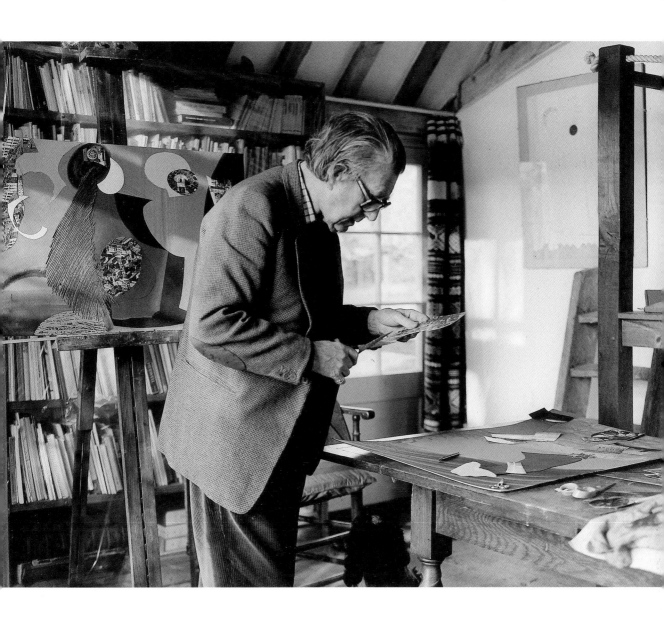

Antony Penrose, Roland Penrose working on Collage in Farley Farm Studio, East Sussex, 1983

91

Notes

1 Roland Penrose, radio interview with Ona Munson, *In Town Tonight at the Celebrity Room*, Los Angeles, August 1946.
2 Elizabeth Cowling, *Visiting Picasso: The Notebooks and Letters of Roland Penrose* (London: Thames & Hudson, 2006), p. 25.
3 Carolyn Burke, *Lee Miller: A Life* (New York: Knopf, 2006), p. 32.
4 *St. Petersburg Times*, 1969, quoted in Burke, p. 40.
5 Ibid., p. 41.
6 For a history of Hallie Flanagan and the Works Projects Administration, see film, *Cradle Will Rock* (1999), directed by Tim Robbins.
7 Lee Miller, radio interview with Ona Munson, *In Town Tonight at the Celebrity Room*, Los Angeles, August 1946.
8 *The Surrealist and the Photographer: Roland Penrose and Lee Miller* (exh. cat.) (Edinburgh: National Galleries of Scotland, 2001), p. 32.
9 Roland Penrose, interview with Edward Lucie-Smith, 1980.
10 Antony Penrose, *Roland Penrose: The Friendly Surrealist* (Munich/London/New York: Prestel, 2001), pp. 18–21.
11 Ibid., p. 23.
12 Roland Penrose, interview with Edward Lucie-Smith, 1980.
13 Ibid.
14 Ibid.
15 Cf. "As beautiful as the chance encounter of a sewing machine and an umbrella on a dissecting table", Comte de Lautréamont, *Les Chants de Maldoror*.
16 Amei Wallach, *Vogue* Magazine, "Krasner's Triumph," November, 1983, p. 501.
17 Roland Penrose, interview with Edward Lucie-Smith, 1980.
18 Tanja Ramm, conversation with Antony Penrose, June 9, 1984.
19 Dickram Tashjian, "Surrealism in the Service of Fashion", in *A Boatload of Madmen: Surrealism and the American Avant Garde 1920–1950* (New York: Thames & Hudson, 1995), p. 68.
20 Estrella de Diego, *The Lost Bodies: Photography and the Surrealists* (Barcelona: La Caixa), 1995 p. 207.
21 Whitney Chadwick, *Women Artists and the Surrealist Movement* (London: Thames & Hudson, 1997), p. 161.
22 Roland Penrose, *Scrap Book 1900–1981* (London: Thames & Hudson, 1981), p. 106.
23 Roland Penrose, interview with Edward Lucie-Smith, 1980.
24 Ibid.
25 Penrose, *Scrap Book 1900–1981*, p. 108.
26 Letter of October 4, 1937 from Lee Miller in Marseille to Roland Penrose in England. The Lee Miller Archives.
27 Letter of October 5, 1937 from Lee Miller in Marseille to Roland Penrose in Hampstead. The Lee Miller Archives.
28 Letter of October 6, 1937 from Roland Penrose in London to Lee Miller in Alexandria. The Lee Miller Archives.
29 Letter of October 14, 1937 from Roland Penrose in Hampstead to Lee Miller in Cairo. The Lee Miller Archives.
30 Letters of October 15 and 22, 1937 from Lee Miller in Cairo to Roland Penrose in Hampstead. The Lee Miller Archives.
31 Letter of October 27, 1937 from Roland Penrose in London to Lee Miller in Cairo. The Lee Miller Archives.
32 Letter of November 14, 1937 from Roland Penrose in Hampstead to Lee Miller in Cairo. The Lee Miller Archives.
33 Roland had just acquired the Gaffé collection through Messens.
34 Lee refers to their holiday together in Lambe Creek, Beacus's house in Cornwall.
35 Letter of November 9, 1937 from Lee Miller in Cairo to Roland Penrose in London. The Lee Miller Archives.
36 Letter dated October 18, 1938 from Lee Miller in Cairo to Roland Penrose in London. The Lee Miller Archives.
37 Antony Penrose, *The Lives of Lee Miller* (London: Thames & Hudson, 1985), p. 103.
38 Sylvain Roumette DVD, *Lee Miller ou la traversée du miroir*, 2006.
39 Penrose, *Roland Penrose*, p. 101.
40 Antony Penrose, *The Legendary Lee Miller, Photographer 1907–1977* (East Sussex: The Lee Miller Archives, 1998), p. 19.
41 Antony Penrose, (ed.) and David E. Scherman, (foreword), *Lee Miller's War: Photographer and Correspondent with the Allies in Europe 1944–45* (London: Thames & Hudson, 2005), p. 129.
42 Lee Miller, *Vogue*, March 1945, p. 50.
43 Penrose, *Lee Miller's War*, p. 188.
44 *Life* magazine, January 7, 1946.
45 Letter of January 15, 1946 from Roland Penrose in Hampstead to Lee Miller in the Balkans. The Lee Miller Archives.
46 Undated letter (August 1945) from Lee Miller in Paris to Roland Penrose (unsent). The Lee Miller Archives.
47 Mémorial des martyrs de la Déportation, Square Ile de France, Paris. Text carved in stone on wall of crypt built in 1962 in memory of the 160,000 people in France deported to the Nazi concentration camps.
48 See Anthony Feinstein, *Journalists Under Fire: The Psychological Hazards of Covering War* (Baltimore, The Johns Hopkins University, 2006).
49 Penrose, *Scrap Book 1900–1981*, p. 138.
50 Roland Penrose, interview with Edward Lucie-Smith, 1980.
51 Cowling, *Visiting Picasso*, p. 101.
52 Penrose, *Roland Penrose*, p. 80.

Selected Bibliography

Burke, Carolyn. *Lee Miller: A Life*. New York: Knopf, 2006.

Calvocoressi, Richard. *Lee Miller: Portraits from a Life*. London: Thames & Hudson, 2002 (paperback edition: 2005).

Calvocoressi, Richard and David Hare. *Lee Miller: Portraits*. London: National Portrait Gallery, 2005.

Chadwick, Whitney. *Women Artists and the Surrealist Movement*. London: Thames & Hudson, 1997.

Cowling, Elizabeth. *Visiting Picasso: The Notebooks and Letters of Roland Penrose*. London: Thames & Hudson, 2006.

Deriaz, Diane. *La Tête à l'Envers*. Paris: Albin Michel, 1988.

Feinstein, Anthony. *Journalists Under Fire: The Psychological Hazards of Covering War*. Baltimore: The Johns Hopkins University, 2006.

Haworth-Booth, Mark. *The Art of Lee Miller*. London: V & A Publications, 2007.

Penrose, Antony. *The Legendary Lee Miller, Photographer 1907–1977*. East Sussex: The Lee Miller Archives, 1998.

Penrose, Antony. *The Lives of Lee Miller*. London: Thames & Hudson, 1985.

Penrose, Antony. *Roland Penrose: The Friendly Surrealist*. Munich/London/New York: Prestel, 2001.

Penrose, Antony. *The Home of the Surrealists: Lee Miller, Roland Penrose and their circle at Farley Farm*. London: Frances Lincoln, 2001.

Penrose, Antony (ed.) and David E. Scherman (foreword). *Lee Miller's War: Photographer and Correspondent with the Allies in Europe 1944–45*. London: Thames & Hudson, 2005.

Penrose, Roland. *The Road Is Wider Than Long*. London: London Gallery, 1939 (reprinted 1980 and 2003).

Penrose, Roland. *Scrap Book 1900–1981*. London: Thames & Hudson, 1981.

The Surrealist and the Photographer: Roland Penrose and Lee Miller (exh. cat.) Edinburgh: National Galleries of Scotland, 2001.

Author's Acknowledgments

My gratitude to friends and family for their loving support, in particular to Suzanne, Nancy, Elena, and Whitney whose contributions to my life are irreplaceable; to my mother Elaine who has always been an inspiration; and to Jesús Vilallonga for his endless joy in life and art. Antony Penrose has been a true friend: we started on this book together and he has supported me every step of the way with his constant faith, generosity, and camaraderie. Special thanks to the extended Penrose–Steele family for their gracious warmth and hospitality. Many thanks to Arabella Hayes, Carole Callow, and Lance Downie at the Lee Miller Archives and Roland Penrose Estate; to Philippa Hurd for her sensitive editing; and to everyone who generously answered my queries.

1900 Roland Penrose is born in St John's Wood, London, on October 14 to Elizabeth Josephine Peckover and James Doyle Penrose, the third of four sons.

1907 Elizabeth Miller is born in Pough-keepsie, New York, on April 23 to Frances MacDonald and Theodore Miller, the middle child between two brothers.

1908 The Penrose family moves to Oxhey Grange, a large estate near Watford, Hertfordshire

1914 World War I begins. | Elizabeth is raped.

1918 Roland joins the Friends' Ambulance Unit and is sent to Italy. | World War I ends.

1925 Elizabeth departs for Paris for the summer with her French teacher as chaperone and attends L'Ecole Medgyès pour la Technique du Théâtre that fall.

Roland and Valentine Boué are married.

1926 Elizabeth returns to New York. Roland sees Max Ernst's *Histoire Naturelle* and describes the experience as "like waking up in another country."

1927 Elizabeth (now going by the name of Lee) is discovered by Condé Nast. She appears on front cover of *Vogue* (March issue) and is photographed by Steichen, Genthe, and Muray.

1928 Roland has his first one-man exhibition held at Galerie van Leer in Paris. Photograph of Lee by Steichen is used in Kotex ad in top fashion magazines.

1929 Lee and friend Tanja Ramm depart for Paris, then to Florence and Rome to study art. Lee returns to Paris, meets Man Ray and becomes his student, model, and lover.

1930 Lee establishes herself in Paris as a photographer in her own right with a studio at 12, rue Victor Considérant and stars in Jean Cocteau's film *Le Sang d'un Poète*. | Roland has a small role in Buñuel's film *L'Âge d'Or*.

1931 Lee visits London to do stills work at Elstree Studios for July 1 issue of the *Bioscope*; photographs sports clothes for June issue of *Vogue*; exhibits at Groupe Annuel des Photographes, Galerie de la Pléiade, Paris; and meets Egyptian Aziz Eloui Bey.

1932 Lee exhibits in group show, *Modern European Photographers*, at Julien Levy Gallery, New York and *International Photographers*, Brooklyn Museum. Lee parts from Man Ray, closes her Parisian studio, and returns to US. Lee has first solo exhibition at Julien Levy Gallery. | On arrival in New York Lee sets up own studio at 8 East 48th St., New York. | Roland and Valentine go to India.

1933 Lee meets and photographs John Houseman, Virgil Thompson, Joseph Cornell, Gertrude Lawrence, and other celebrities.

1934 Lee marries Aziz Eloui Bey on July 19 and after a honeymoon at Niagara Falls, the couple move to Egypt.

1936 Lee photographs during trips to the desert.
Roland organizes the International Surrealist Exhibition in London and meets Picasso for the first time in August. In October he travels with Valentine and David Gascoyne to Barcelona at the invitation of the Catalan government's propaganda ministry to gather evidence to refute the claim that the Republicans were destroying art.

1937 Lee's brother Erik Miller and his wife Mafy move to Cairo.
Lee goes to Paris and meets Roland at a fancy dress ball. They travel to Cornwall and Mougins, France with Man Ray, Dora Maar, Picasso, Eileen Agar, and the Eluards. | Picasso paints six portraits of Lee as L'Arlésienne. Roland makes his first collages using patterns of seaside postcards.

1938 Roland buys The London Gallery in Cork Street and begins publishing the *London Bulletin*, dedicated to Surrealism in Britain. Lee arranges to meet Roland in Athens, and they travel together through the Balkans photographing village life in remote areas.

1939 Roland has second one-man exhibition at the Mayor Gallery, London. | Roland visits Lee in Egypt, and they travel to Siwa and other oasis villages. | Lee parts amicably from Aziz Eloui Bey and moves in with Roland at 21 Downshire Hill, Hampstead, London. They travel to the South of France to visit Max Ernst, Lenora Carrington, Picasso, and Dora Maar, then return to England at the outbreak of war.

1940 German bombing of London begins. Lee joins staff of *Vogue* as a freelancer and photographs fashion and scenes from the Blitz, later to be used in *Grim Glory: Pictures of Britain under Fire*, published in Britain and the US. | David E. Scherman arrives in England as *Life* photographer, and moves into Downshire Hill with Lee and Roland. | Roland becomes a War Office lecturer in camouflage to the Home Guard.

1941 Germany declares war on the US. Roland publishes *Home Guard Manual of Camouflage*. | Lee photographs *Fashion for Factories* for British *Vogue* in June.

1942 Lee becomes accredited as US Forces War Correspondent and takes photographs for her book *Wrens in Camera*.

1943 Lee publishes *At the Other End of the Lens* with Margaret Bourke-White for British *Vogue* in January. | Lee photographs cover of American *Vogue* in July. Lee publishes *In Town this Summer* in British *Vogue* in July.

1944 Lee publishes first photojournalism article on Edward R. Murrow in *Vogue*, followed by *Unarmed Warriors* in September; then *The Siege of St. Malo* in October. Lee teams up with David E. Scherman and publishes further *Vogue* stories: **November** *The Way Things Are In Paris Loire Bridges* **December** *Players in Paris*

1945 January *Patterns of Liberation* | **February** *Brussels — More British than London* **March** *Colette* **April** *Through the Alsace Campaign* **June** *Scales of Justices; Germany The War That Is Won* **July** *Hitleriana; In Denmark Now* | After the Liberation of Paris, Roland flies to Paris for a reunion with Picasso, Lee, Eluard, and other friends. | World War II ends. | Roland publishes *In the Service of the People: French Intellectuals and the Resistance* (Heinemann). | Lee travels to Vienna, covers children dying in hospital.

1946 Lee continues on to Budapest, covers plight of deposed aristocrats; execution of Lazlo Bardossy. On to Bucharest, Romania; photographs king and queen mother, and returns home via Paris to a heroine's welcome from *Vogue* staff. | Roland, Herbert Read, and Peter Watson found the Institute of Contemporary Arts (ICA) in London.
Lee and Roland travel together to US. Lee photographs Isamu Noguchi in New York. They visit Max Ernst and Dorothea Tanning in Arizona, Erik and Mafy Miller (Erik now chief photographer for Lockheed Aircraft Corporation), and Man Ray and Juliet Browner in Los Angeles.

1947 Lee and Roland move across the street to 36 Downshire Hill. | Aziz Eloui Bey travels to England and divorces Lee. | Lee and Roland marry on May 3 at Hampstead registry office. | September 9 Lee gives birth to son Antony and writes about the experience for April 1948 issue of *Vogue*.

1948 Lee covers Venice Biennale for August *Vogue*. | Roland begins organizing the ICA's exhibitions.

1949 Lee writes about the ICA show, *Forty Thousand Years of Modern Art* for January *Vogue*. | Roland has third one-man exhibition at The London Gallery. Roland purchases Farley Farm in Chiddingly, East Sussex.

1950 ICA officially opens in Dover Street, London. | Lee photographs for *James Joyce's Dublin*, published in *Vogue*. Picasso comes to England and visits Farley Farm.

1951 Lee writes on Roland's ICA exhibition celebrating Picasso's 70th birthday for November issue of *Vogue*. Roland publishes book *Homage to Picasso on his 70th Birthday: Drawings and Watercolours since 1893*.

1953 Lee writes and photographs life at Farley Farm for *Working Guests* in July issue of *Vogue*.

1954 Roland is commissioned by Victor Gollancz to write *Picasso, His Life and Work*. Lee photographs for the book.

1955 Lee exhibits in the *Family of Man*, Museum of Modern Art, New York (and world tour).

1956 Roland's book, *Portrait of Picasso*, is published. | Roland is appointed British Council Fine Arts Officer in Paris. | Lee continues to photograph Picasso and other artist friends.

1958 *Picasso, His Life and Work* is published by Gollancz, the first comprehensive biography on Picasso. Editions follow in US, Spain, France, Italy, and Japan.

1960 Roland curates, writes catalogue, and supervises the hanging of the largest Picasso show to date at the Tate Gallery, London.

1961 Lee, now an established gourmet cook, wins a trip to Norway in a competition at the Norwegian Food Centre. Roland publishes three books: *Pablo Picasso: Four Themes*, *Picasso: Early Years*, and *Picasso: Later Years*

1965 Roland publishes book *Picasso: Sculptures*.

1966 Roland is knighted and they become Sir Roland and Lady Lee Penrose. | Articles about Lee appear in *Vogue*, *Studio International*, and *House and Garden*. | Lee and Roland travel extensively to Japan, Spain, and elsewhere.

1967 *Picasso Sculpture* exhibition curated by Roland at the Tate Gallery. Roland publishes *The Eye of Picasso*.

1968 The ICA opens its new premises in the Mall.

1970 Roland's monograph, *Miró*, is published.

1973 Lee photographs Antoni Tàpies for Roland's biography of the artist. Roland edits and contributes to *Picasso: 1881–1973*, later republished as *Picasso in Retrospect* (1981).

1976 Lee's photographs are in the exhibition, *Photographs from the Julien Levy Collection*, at The Art Institute of Chicago. Lee is diagnosed with cancer.

1977 Lee's work is included in *The History of Fashion Photography*, organized by the International Museum of Photography, George Eastman House, Rochester, New York. | Lee dies at Farley Farm on July 27.

1978 Roland's *Tàpies* is published in Barcelona, and in Paris and London the following year.

1981 Roland publishes his autobiography, *Scrap Book 1900–1981*.

1982 Roland has a one-man exhibition of recent collages at Galerie Henriette Gomès, Paris, and at The Mayor Gallery, London, the following year.

1984 Roland dies at Farley Farm on April 23.

© Prestel Verlag,
Munich · Berlin · London · New York, 2007

© for original text by Katherine Slusher,
2007

© for the works by Roland Penrose,
Roland Penrose Estate, England 2007.
All rights reserved.
www.rolandpenrose.co.uk

© for the works by Lee Miller,
Lee Miller Archives, England 2007.
All rights reserved. www.leemiller.co.uk

Prestel Verlag
Königinstrasse 9, D-80539 Munich
Tel. +49 (89) 38 17 09-0
Fax +49 (89) 38 17 09-35
www.prestel.de

Prestel Publishing Ltd.
4, Bloomsbury Place, London WC1A 2QA
Tel. +44 (020) 7323-5004
Fax +44 (020) 7636-8004

Prestel Publishing
900 Broadway, Suite 603
New York, N.Y. 10003
Tel. +1 (212) 995-2720
Fax +1 (212) 995-2733
www.prestel.com

Library of Congress Control Number:
2006938692

The Deutsche Bibliothek holds a record of
this publication in the Deutsche National-
bibliographie; detailed bibliographical data
can be found under: http://dnb.dde.de

Prestel books are available worldwide.
Please contact your nearest bookseller
or one of the above addresses for infor-
mation concerning your local distributor.

Editorial direction: Philippa Hurd

Design, layout and typesetting: WIGEL,
Munich

Origination: Repro Ludwig, Zell am See,
Austria

Printing and binding: Passavia, Passau

Printed in Germany on acid-free paper

ISBN 978-3-7913-3762-3